EDINBURGH NEW TOWN
A COMPREHENSIVE GUIDE

JAN-ANDREW HENDERSON

AMBERLEY

ABOUT THE AUTHOR

Jan-Andrew Henderson is the author of the non-fiction books *The Royal Mile: A Comprehensive Guide*, *The Town Below the Ground: Edinburgh's Legendary Underground City*, *The Emperor's New Kilt: The Two Secret Histories of Scotland*, *The Ghost That Haunted Itself: The Story of the Mackenzie Poltergeist*, *Edinburgh: City of the Dead* and *Black Markers*. He is also a children's novelist whose last three YA thrillers were shortlisted for twelve literary awards and won the Royal Mail and Doncaster Book Prizes. www.janandrewhenderson.com

For Charlotte

First published 2018

Amberley Publishing
The Hill, Stroud
Gloucestershire, GL5 4EP

www.amberley-books.com

Copyright © Jan-Andrew Henderson, 2018

The right of Jan-Andrew Henderson to be identified as the Author of this work has been asserted in accordance with the Copyrights, Designs and Patents Act 1988.

ISBN 978 1 4456 7412 4 (print)
ISBN 978 1 4456 7413 1 (ebook)

British Library Cataloguing in Publication Data.
A catalogue record for this book is available from the British Library.

Origination by Amberley Publishing.
Printed in the UK.

Contents

INTRODUCTION

As far as I am acquainted with modern architecture, I am aware of no streets which, in simplicity and manliness of style, or general breadth and brightness of effect, equal those of the New Town of Edinburgh.

John Ruskin (1890–1900)

All visitors to Edinburgh compare its Old and New Towns, and the latter often comes off unfavourably. The clue is in the name, really. The Old Town (which is pretty much the Royal Mile) has existed since antiquity and boasts a past filled with war, famine, plague, violence and intrigue. The New Town has only been around since the eighteenth century. It's certainly impressive to look at, with a lot of lovely buildings. But, historically, many consider it a little bit … boring.

Only, it's not. Like the Old Town, it's a World Heritage Site and equally fascinating if you know where to look. To be perfectly honest, the New Town is actually more ancient than the Old Town. It hasn't really changed over the centuries, whereas a good three quarters of the Royal Mile has either burned to the ground, been extensively renovated or knocked down and rebuilt entirely.

Then there's the other comparison, one that Edinburgh prefers not to mention. The Royal Mile's past, no matter how colourful, is mainly a story of failure: disastrous invasions of England, numerous occupations, botched political machinations, incompetent monarchs, atrocious living conditions, multiple fires, poverty, overcrowding, disease and crime.

The New Town, on the other hand, is a superb accomplishment. An architectural marvel, it was the hub of Edinburgh when the city was the centre of the flourishing Scottish Enlightenment and Scotland led the world in architecture, civil engineering, political thought, medicine, law, philosophy, economics and education. And it's still a harmonious blend of residential, commercial and business premises, largely missing the tartan tat and tourist-inspired frippery that plagues the Royal Mile.

So, here's a comprehensive guide to the New Town. The movers and shakers who lived here. All the main streets and most of the smaller ones. The significant buildings and monuments, noted pubs, restaurants and visitor attractions. It's got fun facts, a handy interest rating and even lists haunted sites, of which Edinburgh is particularly proud. It's a companion piece to my *Royal Mile: A Comprehensive Guide* and, once you have both, you've got the best bits of the city pretty much covered.

There's no particular route marked out, as everything is worth seeing. For the sake of convenience, however, I've missed a few of the smaller or less appealing streets and fringe areas – unless you've got a couple of days to explore, you won't have time to visit

them all and there simply isn't space in this book for the huge amount of ground the New Town covers. Therefore, I've cherry picked, so you don't have to. You're welcome.

Don't restrict yourself to the places mentioned; venture on your own down some of the roads less travelled. Around every corner there's an unexpected and pleasant surprise … as you'll soon find out.

Jan-Andrew Henderson, 2018

A BRIEF HISTORY OF
THE NEW TOWN

This (New Town) is the Scottish Enlightenment given physical form.

Alexander McCall Smith (b. 1948)

For much of Edinburgh's long existence, there was only the Old Town. Perched on a high basalt ridge, it slowly turned from a collection of rude cottages with a fort at the top and arable slopes on either side, to a collection of towering tenements clinging to the ridge. A wild, sooty dragon with Edinburgh Castle at its head. This was the perfect defensive site and Scotland's history was a turbulent one, so the Old Town never really expanded; it just got more and more crowded. Surrounded by a fortified wall, the greenery disappeared under a rash of tenements, which grew so high they were the tallest in Europe, reaching fifteen storeys in some spots. People lived in underground cellars and tunnels, sanitation was non-existent, the dwellings were rickety fire hazards and living conditions utterly deplorable. By the time the New Town came along, the Royal Mile's glory days were fading. A large number of Edinburgh aristocrats and ambitious, well-educated innovators had taken off for London, no longer willing to live in such a dirty, smelly, violent place.

North of the city, however, were vast swathes of pastoral land, which contained nothing but a few hardy farms and villages, joined by rutted lanes. Separated from the Royal Mile only by the pungent expanse of the sewage-filled Nor' Loch, it was too tempting a prize to ignore.

There had been mutterings, rumours and even proposals in the past about extending Edinburgh, but it took a number of specific events for everything to fall into place. Some were external. The Union of the Crowns in 1603 and then the Union of Parliaments in 1707 meant England had become an ally rather than an enemy. The last military threat to Edinburgh ended with Bonny Prince Charlie's failed Jacobite rebellion of 1745. Now the Old Town walls could finally be taken down and the city safely spread out.

Others were internal. The collapse of a prestigious tenement in 1751, the realisation of just how neglected the buildings had become and subsequent reports on appalling Old Town living conditions made it imperative that new developments be instigated. Along with Glasgow, Edinburgh was the focal point of the Scottish Enlightenment and still teeming with men of learning. Though the crowded conditions in the Old Town had actually been a perfect cauldron for brilliant ideas and innovation, better living conditions were deemed essential if all those geniuses were to be persuaded to stay. In 1752 a pamphlet called *Proposals* by Sir Gilbert Minto (1693–1766) argued that a nice new northern development was just the ticket to stop a potential brain drain and bring the cream of Edinburgh society back.

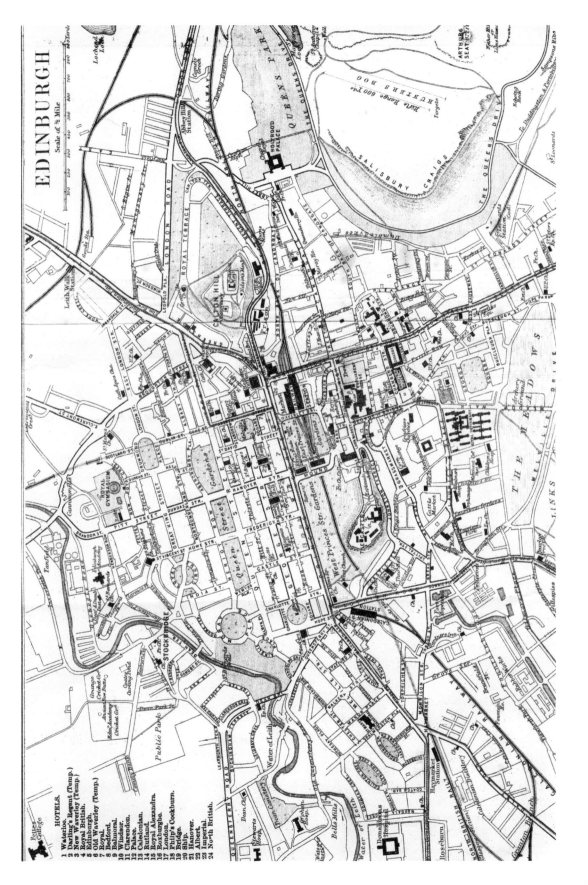

EDINBURGH

Scale of ½ Mile

HOTELS.

1 Waterloo.
2 Darling's Regent (Temp.)
3 New Waverley (Temp.)
4 Royal British.
5 Edinburgh.
6 Old Waverley (Temp.)
7 Royal.
8 Bedford.
9 Balmoral.
10 Windsor.
11 Clarendon.
12 Palace.
13 Caledonian.
14 Royal Alexandra.
15 Royal.
16 Roxburghe.
17 London.
18 Philp's Cockburn.
19 Bridge.
20 Ship.
21 Hanover.
22 Albert.
23 Imperial.
24 North British.

This required more than a new area to inhabit. It called for something to equal or even surpass the finest suburbs of London. Nothing parochial. British rather than Scottish, to give a cosmopolitan feel. And classical. After all, you couldn't beat the Greeks and Romans at that sort of thing. The man who got the ball rolling properly was Lord Provost George Drummond (1688–1766). His tentative first step was to build a gateway between the Royal Mile and the flat, open lands ripe for development: the North Bridge. Next, Drummond needed a builder with a grand plan. So, in 1766, the city launched a competition to design a New Town for Edinburgh.

The winner was a little-known architect named James Craig (1739–95), only twenty-six at the time. His layout wasn't exactly earth shattering, merely a simple grid structure of three parallel main streets with a large square at either end. But it was loaded with allegory, (very) roughly mimicking the Union Jack and symbolizing the union of Scotland and England under the reigning king, George III (1738–1820). The main street, of course, was George Street. (No prizes for guessing who it was named after.) It was flanked by Queen Street in the north (for his wife, Charlotte) and Princes Street in the south (for his son). The squares at either end of the grid (St George and St Andrews) were to be named after the patron saints of both countries. However, there was already a George Square in the south so, it was renamed Charlotte Square to keep in with the royals even more. In between the major thoroughfares were smaller lanes for shopkeepers and less wealthy patrons, aptly named Rose Street and Thistle Street, after the national emblems of England and Scotland. It was British unity portrayed in stone.

But the New Town was also symbolic of the Scottish Enlightenment and its beliefs: that society and its environment could be improved by logical and pragmatic thinking. Though grand in scale, the layout was deliberately functional and uncomplicated and the buildings were also intended to reflect that ethos. The land was given out by a process called fueing, a method where people or developers could buy plots to build on, so long as they stuck to the overall vision.

Rather than the organic, messy development of most cities, the New Town's careful planning meant long vistas and plentiful green space at regular intervals. A great part of the development has a unified frontage, giving the impression that entire terraces are one giant palace, especially in later developments. Major landmarks could be constructed and even dominate their particular street, but they mustn't look out of place. Given those restrictions, the result could have been painfully dull. Fortunately, that didn't happen.

Almost from the beginning, human nature began to foil the grand design. For instance, Craig had envisioned two large churches in the squares at either end, but Sir Lawrence Dundas (1710–81) spotted that the site of St Andrew's Church was a prime location, with a view right down George Street. In 1774, he bought the land, built his house there, and the church had to be moved to George Street instead. This, and many other small irregularities, gave the New Town genuine character, without turning it into an architectural dog's dinner.

A natural reluctance by Edinburgh's citizens to embrace change meant that it took almost fifty years to finish the first New Town. But the result was stunning and the influx slow and steady. Ironically, the aristocrats Scotland hoped to entice back avoided the place, since they couldn't plonk some stately home with a mile-long driveway in the middle of such a carefully regulated area. This was no great loss, for it was the wealthy

and cultured middle class who were most enthused by the ideals and aspirations of the Scottish Enlightenment. And they loved the place.

This, in some ways, is the great irony of the New Town. In my opinion, the truly innovative ideas of the Enlightenment came out of the Old Town. Carried to the New World, they found a receptive audience in the thousands of Scots Irish and Scottish Presbyterians who had relocated there. This irrevocably shaped the culture and national character of what would become the most powerful country in the world: the USA.

Understandably, the occupants of the New Town were less radical, happy to keep up the momentum that had started on the Royal Mile. The Enlightenment's 'Scottish School' of thought argued that we were ultimately creatures of our environment – and what an environment the residents now had. Improvers, rather than true innovators, they still had no intention of resting on their laurels. They acquired knowledge like sponges; considered bettering themselves and, ultimately all of society, a necessity; and exuded an unshakeable self-confidence their English neighbours had lost and their predecessors

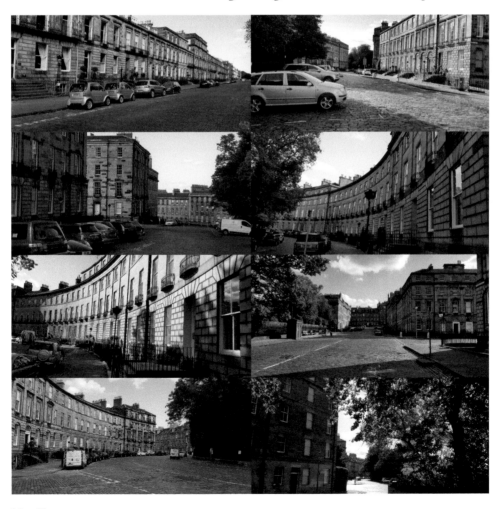

New Town streets.

in the Old Town, brilliant though they might be, had never really known. Along with Glasgow's more freewheeling counterparts, the New Town occupants altered the face of the globe by becoming the practical and intellectual backbone of an even greater force than the USA: the British Empire. In that respect, the New Town was a triumph and a monument to what Scotland could achieve. So, the next move was obvious: expand.

In 1801, the city began building a second New Town to the north of the first, before moving west and east. It is now the largest Georgian development in the world and still as impressive as it was when it was built, except for Princes Street, which looks like Belgrade in the 1960s – but we'll come to that.

The New Town ushered in a different way of life for Edinburgh. Entertaining at home became all the rage now that people had dwellings worth showing off. Though vast amounts of alcohol remained a feature, there were also dinner parties, cards and music recitals, fancy balls at the Assembly Rooms, golf on Bruntsfield Links and horse races at Leith. The city of Edinburgh now had a refined, genteel veneer and the New Town aggressively pushed that image to the fore, despite the Old Town being a total cesspit. That's the sad part, in a way. For the first time, true public division had arrived. Instead of the rich and poor living cheek by jowl, complimenting each other in the generation of groundbreaking ideas, the haves and have-nots were suddenly segregated by distance and class. I feel that's a high price to pay for stability but I won't bemoan it. It's a fact and it happened. This is a guide, not a social commentary.

Civilization had arrived and Edinburgh embraced the fact that it wasn't just riding the coat-tails of Britain's bid to take over the globe; it was leading the charge. The New Town isn't simply an architectural masterpiece but a monument to the body of men (and a few convention-defying women) who changed the entire world.

New Town basements.

ARCHITECTURE

For all its elegant uniformity, the real delight of the New Town lies in its completely unregulated and charming eccentricity.

Magnus Linklater, editor of *The Scotsman* newspaper (b. 1942)

If you're not interested in architecture, look away now. But there's no denying, it's the most impressive thing about the New Town. I'm not going to go into too much specific detail. If structural design is your thing, you already know the difference between a Doric column and a Corinthian one. If not, there's no real point in minutely describing each building, as you're going to be looking at them anyway.

In a nutshell, Georgian architecture flourished between 1714 and 1830, under the rule of the Hanoverian monarchs: George I, George II, George III and George IV. The styles were variable but based on the structures of antiquity, revived during the Renaissance.

This was a great period in British design, reflected in the buildings you'll see. Many of the New Town's builders took the 'Grand Tour' through Europe to Italy, rediscovering classical design and bringing back a form that had been largely ignored since the days of the Roman Empire. And their clients saw themselves as rightful heirs to these glories. With the coming of the Scottish Enlightenment, many sought to model their lives on such ancient principals as virtue, wisdom and harmony. Naturally they wanted to reflect these qualities in their surroundings.

Regularity and uniformity of style and size was imposed by the city elders. Ornamentation was kept to a minimum. The buildings were fronted by droved ashlar, masonry of large blocks wrought to even faces and square edges, then scored with parallel lines made by a broad chisel. The grey stone of local Craigleith Quarry was used to construct developments that were repetitive, conformist and sometimes austere. It certainly wasn't to everyone's taste. The judge and diarist Lord Cockburn (1779–1854) scathingly wrote, 'What a sight did nature give us for its New Town! Yet what insignificance in its plan. What poverty in all its details!' Didn't stop him moving there, though.

As usual, ways were found to beat the system or introduce a bit of individuality. For instance, builders got round a three-storey limit by having rows of attic rooms with windows perched high on the rooftops. And, overall, it worked splendidly. In 1850, Charlotte Bronte (1816–55) contrasted London and Edinburgh as 'prose compared to poetry'. Edinburgh had finally achieved the prestige it craved as a capital city, and the icing on the cake was the perspective of a host of dazzling Scots architects like Robert Adam (1728–1792) and William Playfair (1790–1857). Though they took classic models as a starting point, they carved out a style that was strikingly individual yet undeniably Scottish. Since Edinburgh was now considered the 'Athens of the North', they strove to give it a look worthy of that title.

Above: Nelson Street from Drummond Place.

Left: Scott Monument.

Sorry. I wasn't going to go into details, was I?

Fun Fact The Georgian style was revived in the late nineteenth century in the United States as 'Colonial Revival' and in early twentieth-century Britain as 'Neo-Georgian'.

THE ORIGINAL NEW TOWN

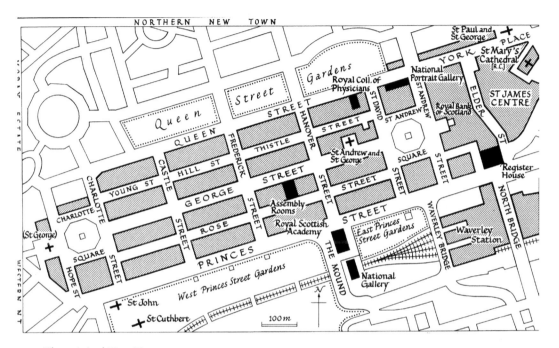

The original New Town.

The original New Town, as envisaged by James Craig, isn't big, but it *is* clever, and it didn't take long for the commercial potential of the site to be utilised. Shops were opened on Princes Street during the nineteenth and twentieth centuries and the majority of the town houses were replaced with commercial buildings. Fortunately, the other major streets still contain most of their original late eighteenth-century buildings.

Edinburgh-born James Craig never really repeated his success in designing the first New Town. He was involved in the planning of a number of expansions but few individual buildings he designed still stand. He may have started the ball rolling but, to be honest, he was followed by peers who were simply better at what they did. An irascible and arrogant man, he fell from favour and died in poverty. Ironically, he is buried in Greyfriars Kirkyard in the Old Town.

North Bridge

The first connection between the Old and New Towns, North Bridge was constructed between 1763 and 1772 by Scottish architect and engineer William Mylne (1734–90). When part of the structure collapsed in 1769, killing five people, it was built again. Then again. The current bridge was erected between 1894 and 1897 by Sir William Arrol & Co., also responsible for the construction of the Forth Rail Bridge

Interest Rating 4/5

Fun Fact The Rail Bridge was voted Scotland's greatest man-made wonder in 2016 and is also a UNESCO World Heritage Site.

Haunted Rating 3/5

The former *Scotsman* newspaper office on the North Bridge (now the Scotsman Hotel) once had a whole plethora of ghosts. In 1990 a security guard ran into an employee who he knew to be dead. In 1994 a page make-up artist, working in the basement, came across a door he had never seen before. Upon entering he stumbled upon a phantom printer sporting old-fashioned clothes and beard and carrying antiquated printing plates. The building was also haunted by a blonde woman who would vanish anytime a member of staff came over to ask what she wanted. Apparently, there was also a phantom forger.

Then again, you can't believe everything you read in the press.

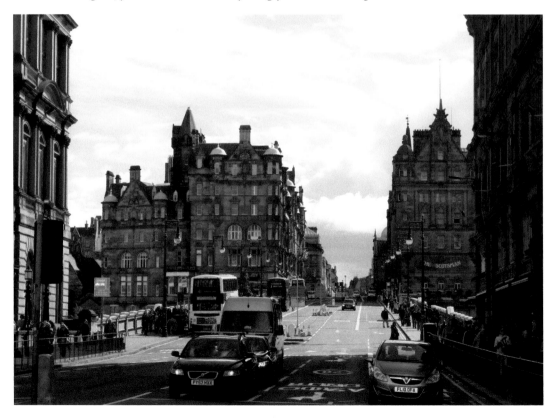

North Bridge.

Princes Street Gardens

The entire south side of Princes Street is taken up by public gardens, originally only for New Town residents. It is set on the site of the former Nor' Loch, a stinking, fetid swamp that was part of Edinburgh Castle's defences and the spot where suspected witches were 'douked'. The logic was devious and perverse. The accused woman (they were usually female) was thrown into the water. If she drowned she was innocent; if she floated, she was guilty and executed. Or she was put in a ducking chair and repeatedly submerged until she confessed: a classic lose-lose scenario.

The Nor' Loch was drained in the early nineteenth century and is now a stunning verdant landscape with a neck-cricking view of the castle. It is filled with monuments to Scottish worthies and their achievements, including the Scottish/American War Memorial, the Royal Scots Memorial and statues of David Livingstone, Adam Black, John Wilson, Allan Ramsay, Dr Thomas Guthrie, Sir James Simpson and Wojtek the Bear. Look them up on Google. I haven't got the space to tell all their stories.

Well. Maybe one ...

Interest Rating 5/5

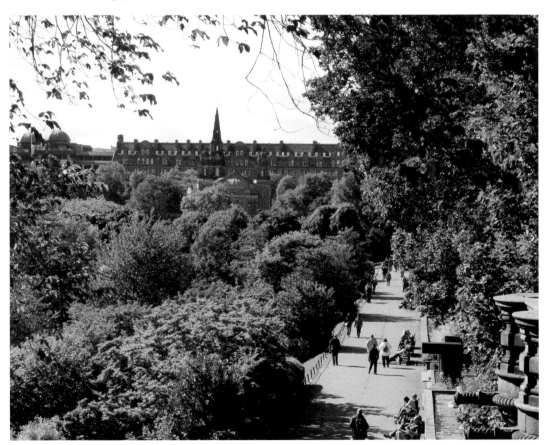

Princes Street Gardens.

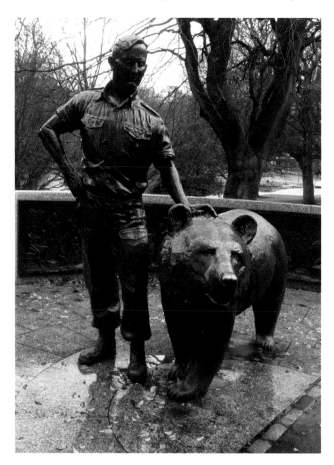

Wojtek the Bear statue.

Wojtek (1942–63) was a Syrian brown bear, purchased as a young cub by Polish soldiers. In order that he could accompany them to Italy, he was officially enlisted as a soldier and eventually promoted to corporal. He served with the Polish Second Corps, moving 100-pound crates of ammunition during the Battle of Monte Cassino in 1944. (No. I'm not making it up.) After the war, he lived out the rest of his life at Edinburgh Zoo.

The Walter Scott Monument

The garden's most famous landmark, this 200-foot-high 'Gothic rocket' is the largest tribute to a writer anywhere in the world. It was designed by self-taught architect George Meikle Kemp (1795–1844), who drowned in the Union Canal before it was finished. Walter Scott is represented sitting with a Border plaid over his left shoulder and his favourite highland staghound, Maida, at his right foot. There is a small spiral staircase leading to the top and a breathtaking view. If you're a fun sort, run all the way down when you're finished. It has the same effect as stepping out of a centrifuge and you will most certainly fall over.

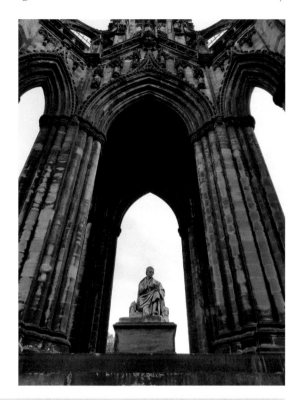

Walter Scott Monument.

Sir Walter Scott (1771–1832) is most famous as the originator of the historical novel. Author of *Ivanhoe* and *Rob Roy*, his anonymously published *Waverley* novels proved hugely popular in Europe and America, established his reputation as a major international literary force, and gave Edinburgh's main train station its name. By the 1820s he was probably the most famous Scot in the world. This was the man who found Scotland's lost crown jewels and organised King George IV's visit to Edinburgh, effectively uniting the highlands and lowlands (*see* Hanover Street). His novels about the rugged north romanticized the highlands and turned them into a tourist destination. He even suggested Edinburgh Castle, rather than remaining just a military base, would make a great visitor attraction.

In 1825 a banking crisis led to the collapse of Ballantyne's printing business, in which Scott had invested his money. Refusing to declare himself bankrupt or accept financial support from his admirers, he tried to write his way out of debt. The strain of keeping up such a prodigious output weakened his health and he eventually succumbed to typhus.

No. 5A Pretty much the only dwelling on the South Side of Princes Street, this picture-postcard cottage is owned by the council and used by the gardener/watchman. If you're under five, it's also the building featured in the children's TV programme *Teacup Tales*. Mind you, if you're under five you're not likely to be reading this book …

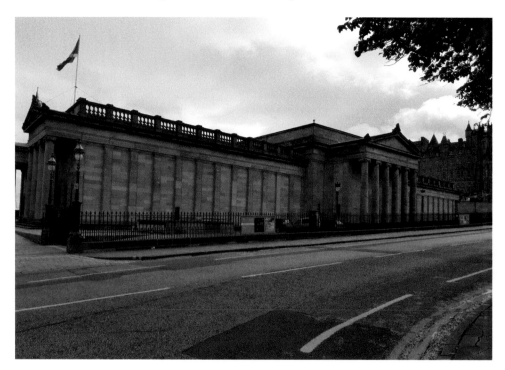

National Gallery of Scotland.

The Mound As the New Town gained popularity, new connections to the Old Town were needed. The result was The Mound. The brainchild of a clothier called George Boyd, it was formed by dumping almost two million cartloads of earth and rubble from the building of the New Town into the ravine of what is now Princes Street Gardens. When 'Geordie Boyd's Mud Brig' was widened for carriages, Boyd's house was demolished because it was in the way. The Mound is now entirely paved over.

National Gallery of Scotland Designed by William Henry Playfair and opened to the public in 1859, this neoclassical building houses the national collection of art, from the beginning of the Renaissance to the start of the twentieth century.

The Royal Scottish Academy Founded in 1819 (as the Royal Institution for the Encouragement of the Fine Arts in Scotland) to promote the country's contemporary art, it was built by William Henry Playfair and extended in 1831–36. Along with the National Gallery of Scotland, it was remodelled in 1912 by William Thomas Oldrieve (1853–1922) and has an imposing statue of Queen Victoria on top, sculpted by Sir John Steell (1804–91).

The Floral Clock Commissioned in 1903, it is the oldest in the world and incorporates almost 50,000 blooms. It takes two gardeners five weeks to plant flowers, from July until October, and even tells the correct time. Every fifteen minutes a cuckoo pops out, if you want a bit of excitement.

The Ross Bandstand Seating up to 2,400 people, the original bandstand was built in 1877 and redeveloped in 1935. It's the prime spot to watch the Edinburgh Festival firework display each summer, if you can get a ticket.

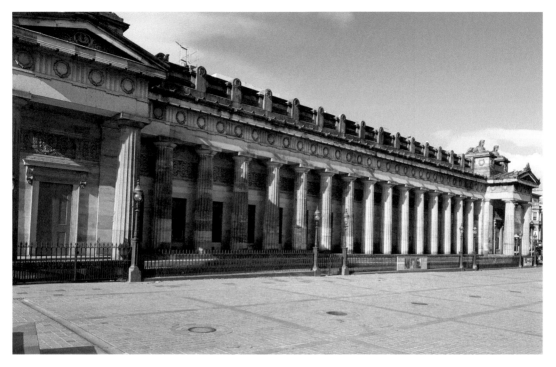

Royal Scottish Academy.

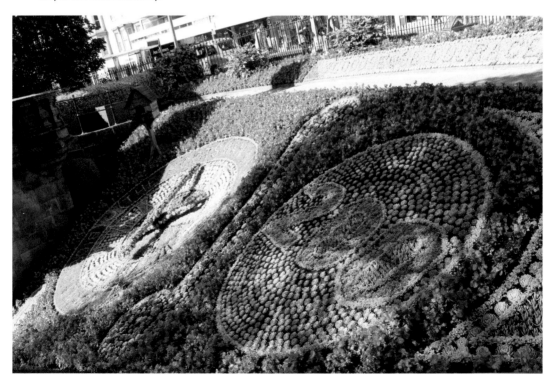

Floral Clock.

The Ross Fountain An incredibly ornate French fancy, cast in 1862 for the Great London Exposition. It was installed in its current position in 1872 and makes for a splendid photo opportunity, with Edinburgh Castle filling the background.

St Cuthbert's Kirk Built in 1894 on the site of a far older church, dating from the eighth century. During his siege of Edinburgh Castle, Oliver Cromwell (1599–1658) made the church a barrack and it was nearly destroyed by the fortress guns. It was repaired and opened for service in 1655. It has a suitably moody graveyard, where Thomas De Quincy (1785–1859), author of *Confessions of an Opium Eater*, is buried. The graveyard also sports a watchtower, once used to prevent grave robbing.

St John's Episcopalian Church Designed by twenty-five-year-old William Burn (1789–1870) and built between 1816 and 1818. The graveyard contains the famous mathematician John Napier (1550–1617), inventor of logarithms.

Haunted Rating 2/5 A crying woman has been reported in the churchyard throughout the twentieth century. Grieving for her murdered husband, she stumbled in front of a horse and carriage on the same spot and was also killed. Some people have no luck.

Princes Street

Princes Street was built over a road known as the 'Lang Dyke', which ran from the east end to the village of Silver Mills, at what is now the west end. Started in 1769, it was the least desirable of Craig's three main streets, the houses being a long row of plain residential terraces. Sure, it had a nice view of the castle but also the dirty, smoky Old Town and the stagnant Nor' Loch (Craig's proposal of building a canal there came to nothing).

The Gardens and Mound are truly impressive, but of all the New Town streets, this one has undergone the most drastic transformation. It is made up almost entirely of large shops and many of the old building fronts have been replaced by glass and concrete. Still, it could be worse. If it were in Dundee, the entire thoroughfare would be a car park by now.

Interest Rating 3/5 (5/5 if there had been less ugly buildings.)

Fun Fact Princes Street was originally to be called St Giles Street, but George III didn't like that, especially since it wasn't named after one of his immediate family. Instead he muttered 'Hey, hey! What, what! St Giles Street! Never do, never do!'

Eloquence wasn't his strong suite.

George III's father, Frederick Prince of Wales, died before ascending the throne, so he succeeded his grandfather, George II, in 1760. The first Hanoverian monarch to use English as his first language, he married Charlotte of Mecklenburg-Strelitz and had fifteen children. Yup, fifteen. After Britain's defeat in the American War of Independence (1775–83), George began to suffer from serious bouts of illness and, eventually, went off his rocker.

Shopfronts, Princes Street.

The Balmoral Hotel Formerly the North British Hotel, this Franco-German-style building, above Waverly Station, was completed in 1902. The 58-metre clock tower is one of Edinburgh's most famous landmarks and is set five minutes fast, to make sure people don't miss their train.

Register House The repository of Scotland's legal and historical records, it was designed by Robert Adam (1728–92), using funds forfeited from the estates of Jacobites, after the failed rebellion of 1745. In front is an 1848 statue of the Duke of Wellington by Sir John Steell. He usually has a traffic cone on his head, which Steell had probably not envisioned.

New Register House This Italianate building contains Scotland's register of births, deaths and marriages.

No. 43 The Old Waverly Hotel Dating from 1847, this is the oldest hotel on Princes Street. It was originally Cranston's Temperance Hotel and banned the sale of alcohol, which must have made it a depressing place to stay.

No. 47 Jenners Department Store When drapery assistants Charles Kennington and Charles Jenner were fired for taking the day off to attend races, they decided to set up their own shop. Jenners Department store is still running to this day, the oldest independent department store in Britain. The original building burnt down in 1892 and was replaced by the pinkish Renaissance-style giant you see now.

No. 128 In the 1980s this was the location of the famous Fire Island gay nightclub, hosting acts like the Village People, Eartha Kitt, Divine, The Three Degrees and Mel & Kim. Even Simon Cowell popped in occasionally, accompanied by his previous partner, Sinitta. It is now a branch of Waterstones. Obviously, I've got nothing against bookstores but, hey, The Village People never played in one.

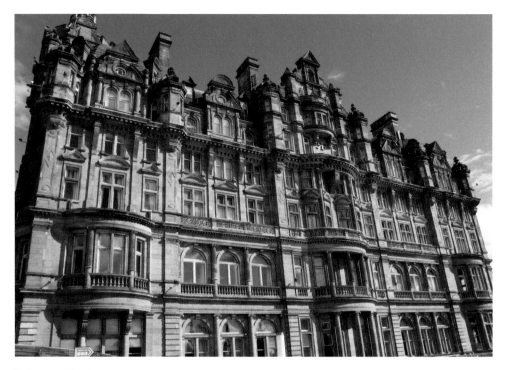

Balmoral Hotel.

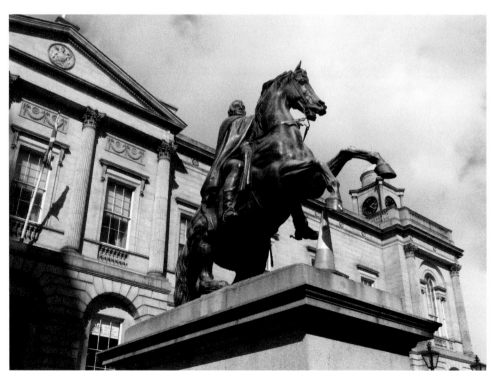

Duke of Wellington statue with Register House and traffic cone.

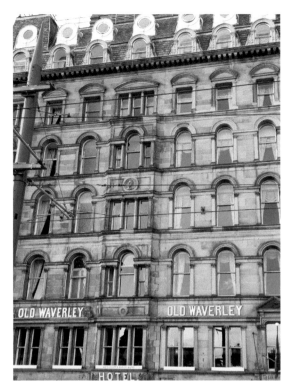

Right: Old Waverly Hotel.

Below: Jenners Department Store.

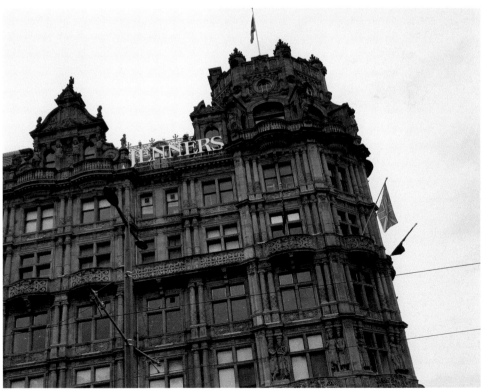

Rose Street

Rose Street was originally used as a service entrance to the grand residential homes on Princes and George streets. In the 1800s, however, it gained a reputation as a seedy backwater, not a place for the respectable to be seen after dark. By the 1960s this had started to change, as tenement flats gave way to antique shops and boutiques and the backs of many large department stores. In 1973 the transformation was completed when the section between Castle Street and Frederick Street became the first pedestrianized thoroughfare in the city.

Nowadays Rose Street, or 'The Amber Mile', is famous for its pubs. The 'Rose Street Crawl' requires visitors to take one drink in each bar all the way along its length. Because *that* doesn't annoy the locals much.

Interest Rating 4/5

No. 100 The Auld Hundred The building started life as a mission hall before being converted for use as pub in 1800, making it one of the oldest bars in the street. 'Auld Hundred' is the name given to the traditional tune of the 23rd Psalm, reflecting its origins.

Nos 152–154 The Kenilworth Bar Another of the street's well-preserved old pubs, with a huge, intricately carved mahogany bar, fab tiles, an ornate ceiling and stained-glass windows. The original pub was designed in 1893 and converted in 1904, taking its name from a novel by Sir Walter Scott. It is considered to be Edinburgh's original gay bar and was a common meeting place for the community in the 1960s.

No. 129 In 1830 McVitie's provision shop opened here, establishing the lauded firm of biscuit manufacturers. Their most famous confection is the legendary Digestive Biscuit.

Rose Street.

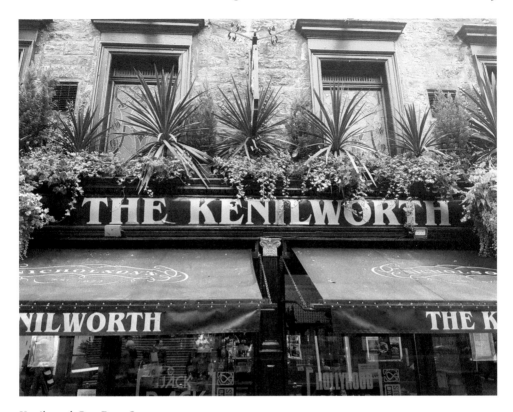

Kenilworth Bar, Rose Street.

Dunk it in tea for exactly five seconds and it's one of the most delicious things you'll ever taste. Any longer and it will dissolve to mush in the cup.

No. 66 After the 'Great Fire of 1824' destroyed a large part of the Old Town, James Braidwood (1800–61) founded Britain's first municipal fire department. This was the site of the Rose Street Station, which covered the New Town and had a team of twelve firemen with a handcart.

St Andrew's Square

In the late eighteenth century, St Andrew's Square was probably the most fashionable address of the New Town. However, it became increasingly commercial until it was known as the 'Golden Square' of the banking industry. It still has a few of the original buildings and façades but, unfortunately, a lot has changed beyond recognition. The bus station, where the square joins St Andrews Street and Elder Street, is a particular eyesore. The garden in the middle is pleasant though, and often hosts exhibitions and art installations.

Interest Rating 3/5

No. 36 Dundas House Formerly the house of Sir Lawrence Dundas, designed by Sir William Chambers (1723–96) and completed in 1774. It was acquired by Royal Bank of Scotland in 1825 and radically altered. Outside is a statue of the 4th Earl of Hopetoun (1765–1823), a hero of the Napoleonic Wars and governor of

the bank. The star-studded interior is certainly not something you expect to find in a financial institution.

The Melville Monument If more evidence were needed that the Dundas family were a bunch of characters, it's right outside. At the centre of the gardens is a huge monument to the man once described as 'the uncrowned king of Scotland', Henry Dundas 1st Viscount Melville (1742–1811).

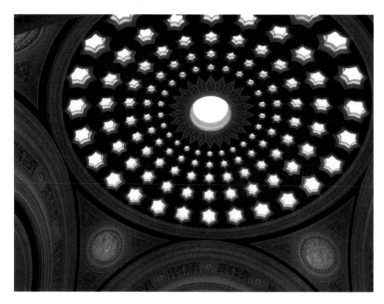

Interior of Royal Bank of Scotland (formerly Dundas House).

Hopetoun and Melville monuments.

Henry Dundas was a Tory politician who held various ministerial offices under William Pitt the Younger (1759-1806), including Secretary for War and First Lord of Admiralty. His expert manipulation of Scottish politics earned him the nickname 'King Harry the Ninth', though he was, less flatteringly, known as the 'Great Tyrant'. He ensured the Transatlantic Slave Trade was allowed to continue, crushed democracy movements and used 'Black Watch' troops to enforce the Highland Clearances. He was finally impeached in 1806 for the misappropriation of public money. Perhaps not really deserving of that huge statue, then. But it's okay; he paid for it himself.

No. 23 Birthplace of Henry Brougham (1778–1868). A writer of scientific articles who became an influential politician, helping to defeat the Tories and restore the Whig Party to power. Arrogant, vain, temperamental and disliked by everyone who met him, he still managed to turn the Whigs into champions for parliamentary, education and social reform. Fittingly, they eventually morphed into the Liberal Party. Brougham was a great supporter of the anti-slavery movement and still holds the House of Commons record for non-stop speaking, at six hours. He also designed a type of horse-drawn carriage, the 'Brougham'.
Fun Fact Brougham is credited with making Cannes a popular holiday resort, after building a house there. A statue of him stands on the waterfront, next to the Palais des Festivals et des Congrès.

Multrees Walk
Created in 2003, the latest addition to the square is a luxury pedestrian shopping precinct off the east side. A bit square and blocky to look at, but ideal for those who want to pay a month's salary for a handbag.
Interest Rating 4/5

Multrees
Walk.

St David's Street

Noted for being the home of philosopher David Hume (1711–76), where he entertained Benjamin Franklin (1706–90) as one of his first guests. There is a well-hidden plaque near Jenners commemorating the spot where his house stood. Hume was well known as an atheist and it is said that a minister friend chalked 'Saint David's Street' on his house as a joke. The name stuck.

Interest Rating 2/5

David Hume was the author of the seminal works *A Treatise of Human Nature*, *An Enquiry Concerning Human Understanding* and *An Enquiry Concerning the Principles of Morals*. In my humble opinion, Hume was one of the greatest philosophers who ever lived and the Scottish Enlightenment's titan. This ardent empiricist argued that all knowledge is founded on experience; that passion, not reason, governs human behaviour and that morals are subjective rather than objective. His atheism and opposition to organised religion was a career-ending, and life-threatening, stance in those days. Despite many attempts, Hume never held an academic post and was excommunicated by the Church, but his influence on Western thought was incalculable. A cheerful man who enjoyed women, lively conversation and drink, he was one of the few original Enlightenment giants who actually moved to the New Town.

West Register Street

Formerly St Andrews Lane, this small winding alley contains two excellent bars. The Parisian-style Café Royal was opened in 1863 and retains its fine Victorian plasterwork and stained glass. The equally impressive Guilford Arms has been owned and operated by the Stewart family since 1896. Apart from these gems it's pretty dingy.

Interest Rating 2/5

Fun Fact This street was home to the eccentric, irritable and foul-mouthed lawyer and historian Hugo Arnot (1749–86), author of *The History of Edinburgh*. When neighbours complained about him ringing a loud handbell to summon his servant he used a pistol instead.

George Street

Built during the 1790s, this was the principal street of the original New Town. Prominent statues commemorate Thomas Chalmers (1780–1847), William Pitt the Younger, King George IV (1762–1830) and James Clerk Maxwell (1831–79). To begin with George Street was a straight country road, with fences on either side, and it took almost three decades before houses completely replaced it. Nowadays it is still an impressive thoroughfare, if a little commercial, with many quality shops and fancy restaurants.

Interest Rating 4/5

Haunted Rating 3/5 Haunted by Jane Vernelt, who lost her shop here after bad financial advice from friends. She has been seen several times heading towards the non-existent property.

St Andrew's Church Opened in 1784, it was the first church to be built in the New Town. Originally intended for St Andrew's Square, it ended up in George Street, after William Dundas nicked the prime spot for his own residence. In 1843, this was the site of the 'Disruption of the Church of Scotland'. Furious by the Civil Courts' infringements on the liberties of the Church of Scotland, one-third of the ministers present at the annual General Assembly walked out of the building. They then formed the Free Church of Scotland, known affectionately as the 'Wee Frees'.

No. 14 The Dome Once the site of the Old Physicians' Hall designed by James Craig. It was demolished, then rebuilt as the headquarters of the Commercial Bank of Scotland in 1847, designed by David Rhind (1808–83) in a Greco-Roman style. It is now a bar and restaurant with a spectacular interior.

No. 18 The first studio of the famous artist Henry Raeburn (1756–1823), who served as portrait painter to King George IV (1762–1830).

Nos 22–26, The Royal Society of Edinburgh At the beginning of the eighteenth century, the Scottish Enlightenment fostered many Edinburgh clubs and societies. The most prestigious of these was the Philosophical Society, founded in 1738. In 1783 this became the Royal Society of Edinburgh, Scotland's national academy of science and letters. It has been at this location since 1909.

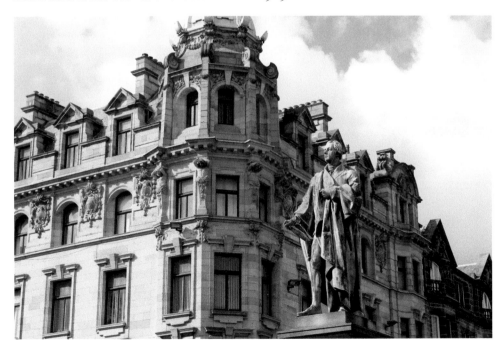

Statue of William Pitt the Younger, George Street.

No. 50 Sir Walter Scott rented a house here after his marriage to Charlotte Carpenter in 1797.

No. 54 Assembly Rooms A meeting place for Edinburgh residents since 1787, it is still a popular venue, especially during the Edinburgh International Arts Festival. The design of the building, begun in 1783, was also decided by a competition. However, the winner, John Henderson, died halfway through construction and the building was finished by his father. It has now been expanded and altered several times. The chandeliers, ceiling roses, mirrors, drapes and fluted Corinthian pilasters were added by John Baxter in 1796, with the grand Portico out front added in 1818.

Fun Fact In 1841 Charles Dickens delighted an Assembly audience by reading his recently penned *A Christmas Carol*. But the locals could be a tough crowd. In 1856, the feted novelist William Thackeray (1811–63) was booed for making disparaging remarks about Mary, Queen of Scots.

No. 60 The poet Percy Shelley (1792–1822) and his sixteen-year-old bride, Harriet Westbrook (1795–1816), stayed here in 1811. A plaque commemorates the event, despite the fact that Shelley was a rude, insensitive know-it-all. The marriage fell apart when Shelley fell in love with another sixteen-year-old, Mary Godwin. Harriet committed suicide and Godwin became Mary Shelley, author of *Frankenstein*.

No. 81, then 95 Home of Eugene Chantrelle (1834–78), a brilliant French academic and thoroughly bad egg. In 1878 he was hanged at Calton Jail for the murder of his wife, who he had insured for £1,000 shortly before. Obviously not *that* brilliant, then.

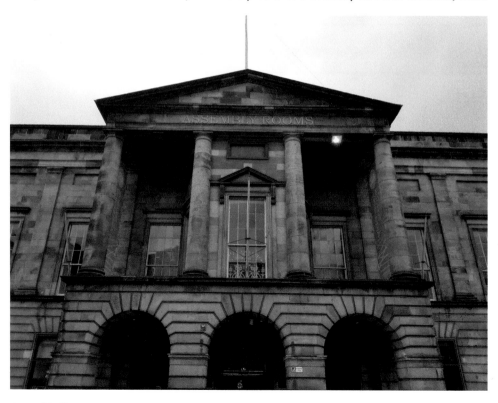

Assembly Rooms.

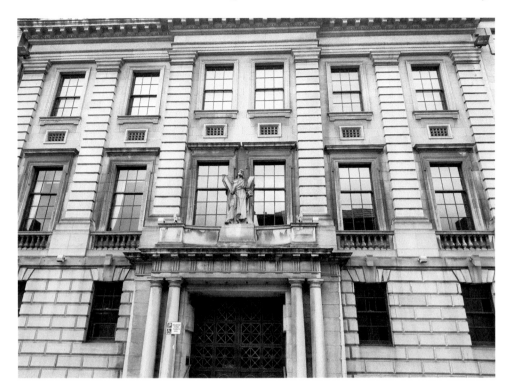

Freemason's Hall, George Street.

No. 96 This is Freemason's Hall, headquarters of the Masonic Grand Lodge of Scotland, the corporate body governing Freemasonry in Scottish Masonic lodges across the world. Built between 1910 and 1912 by A. Hunter Crawford (1865–1945), it replaced the 1858 original hall by David Bryce (1803–76).

Charlotte Square

Designed by Robert Adam, Britain's most respected architect at the time. This was the last section to be built of the First New Town, finally completed in 1820, and is the twin of St Andrew's Square at the other end. The buildings have neoclassical palace-style facades round a circular central garden, creating an impressive, if ascetic, spectacle. Unfortunately, it was also one of the first Scottish developments to incorporate tradesman's entrances, further segregating the working classes from the New Town occupants.

At first, the square housed mainly families from the military or landed gentry. By the 1850s, they were joined by so many medical professionals, it became known as 'The Harley Street of Edinburgh'. The 1900s saw a rise in legal and financial companies, eventually becoming the business hub of Edinburgh. The gardens are private but, each August, they host the Edinburgh International Book Festival.

Interest Rating 5/5

Haunted Rating 3/5 The square has a number of recorded phantoms including a ghost coach, a beggar, a woman and a monk. The sound of ghostly piano playing can also be heard. The possibility that someone in one of the buildings is actually playing the piano has, apparently, never been considered.

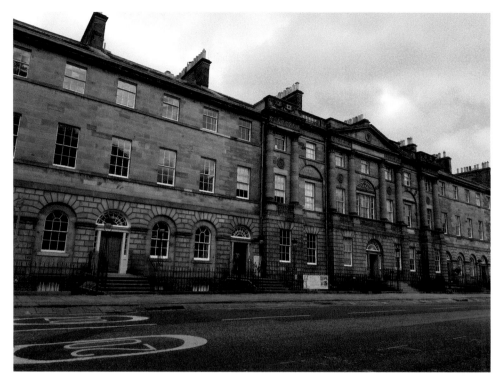

Charlotte Square.

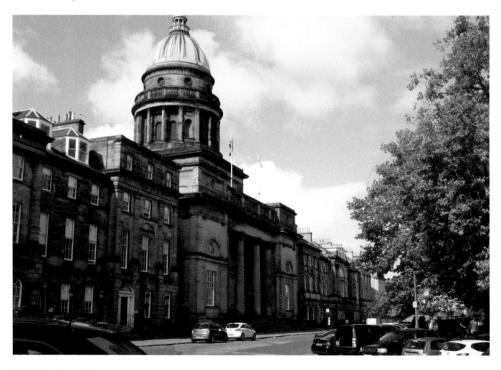

West Register House.

West Register House Formerly St George's Church, this beautiful nineteenth-century domed building is by the king's architect and surveyor for Scotland, Robert Reid (1774–1856). In 1971 it was converted into West Register House to accommodate the city's growing number and variety of records.

No. 6 Known as Bute House, this former hotel is the official residence of Scotland's First Minister.

Son of William Adam, the foremost Scottish architect of his time, Robert Adam and his brothers John and James followed in their father's footsteps. In 1754, Robert embarked on a 'Grand Tour' of Europe, spending five years in France and Italy, visiting ancient sites. On his return, he established a practice with James and became one of the most successful and fashionable architects in the UK. Ambitious and arrogant, he rejected the popular styles of the day and developed classically inspired forms, relying on dramatic contrasts in both his interiors and exteriors. The 'Adamesque' style influenced the development of Western architecture in Europe and North America. The Adams family have a (naturally) classical mausoleum in Greyfriars Graveyard. They are not to be confused with the fictional *Addams Family*.

No. 7 The Georgian House Converted by the National Trust for Scotland to look as it did when the dwelling was first occupied (in 1796). The interior offers a unique glimpse into how New Town inhabitants lived, with a fine collection of period furniture, porcelain, silver and glass.

No. 9 Joseph Lister (1827–1912) lived here from 1870 to 1877. Spotting the connection between lack of cleanliness and deaths on the operating table, he instructed surgeons to wear clean gloves and wash their hands before and after operations. This led to a massive reduction in post-operative infections, earning him the title the 'Father of Modern Surgery'. He also championed the use of carbolic acid as an antiseptic.

No. 14 Home of Lord Cockburn (1779–1854), whose *Memorials of his Time* is a wonderful memoir of life in eighteenth- and nineteenth-century Edinburgh.

No. 24 Birthplace of Field Marshall Earl Haig (1861–1928). A highly controversial figure, he commanded the British Expeditionary Force on the Western Front, from 1915 until the end of the First World War. Though his funeral was a day of national mourning, he has since been nicknamed 'Butcher Haig'. Historians still argue about whether he was a calm pragmatist, dutifully trying to carry out an impossible task, or a callous and stubborn dunderhead. Since he was responsible for overseeing two million British casualties, I'm going for dunderhead.

No. 38 Home of John Learmonth (1789–1858). A Tory politician and chairman of the Edinburgh and Glasgow Railway Co., he was also twice Lord Provost of Edinburgh (*see* Dean Estate).

The Albert Memorial Executed by Sir John Steell in 1876, this statue was commissioned to commemorate the death of Queen Victoria's husband, Albert. Victoria was so delighted with it, she had Steell knighted.

Albert Memorial, Charlotte Square Gardens.

South Charlotte Street

Just off the main square, leading to Princes Street, South Charlotte Street is completely unremarkable. The upper storeys are still impressive but almost all the buildings now have commercial fronts.

Interest Rating 2/5

Haunted Rating 1/5 The daughter of George Lockhart, who once had a mansion here, was said to be possessed by an evil spirit. In 1824 an eyewitness saw her 'climb onto the top of a four poster bed', which, in demonic terms, is really quite tame.

No. 16 The birthplace of Alexander Graham Bell (1847–1922), with a plaque marking the spot. Bell was the inventor of the telephone, editor of the National Geographic Society and founder of the American Telephone and Telegraph Company (AT&T).

Fun Fact Bell's mother and wife were deaf and his real passion was research on hearing and speech. He considered his most famous invention an intrusion on this work and refused to have a telephone in his study. Thank God he didn't live to see mobiles.

North Charlotte Street

North Charlotte Street is just as short but more impressive than its southern counterpart. At the junction with Queen Street is David Bryce's memorial to Catherine Sinclair (1800–64), an acclaimed children's novelist and the woman who (correctly) surmised that Walter Scott was the anonymous writer of the *Waverley* novels. Fittingly, the design is a miniature version of the Walter Scott Monument in Princes Street.

Interest Rating 3/5

Queen Street

The longest stretch of eighteenth Century architecture in Edinburgh, it was named after Queen Charlotte of Mecklenburg (1744–1818), consort of George III. Built to mirror Princes Street, it originally had wonderful views over open fields to the Firth of Forth and the hills of Fife and is still a breathtaking sight, not much different from when it was constructed. Princes Street, on the other hand, looks like it was made out of dirty Lego.

Interest rating 5/5

Queen Street Gardens Running the entire northern length of the thoroughfare, this 7-acre pleasure ground is divided into three sections and even has a small Grecian temple. It was established in 1822 for the exclusive use of homeowners in surrounding streets. If you want to see it, you'll just have to peer over the railings.

No. 1 The Scottish National Portrait Galley This breathtaking Gothic slab sticks out from the surrounding Georgian regularity like a sore thumb. It is made of red sandstone and was designed by Sir Rowland Anderson (1834–1921) to resemble the Doge's Gothic palace in Venice. Inside the central hall is a magnificent frieze of Scottish historical figures by William Hole (1887–1901).

No. 9 A neoclassical building designed by Thomas Hamilton (1784–1858) in 1833, which now houses the Royal College of Physicians. The RCPE was formed in 1681, with Sir Robert Sibbald (1641–1722) playing a key part in gaining it a royal charter. In 1920 the college allowed women to be admitted on the same terms as men. Which was nice of them.

Queen Street.

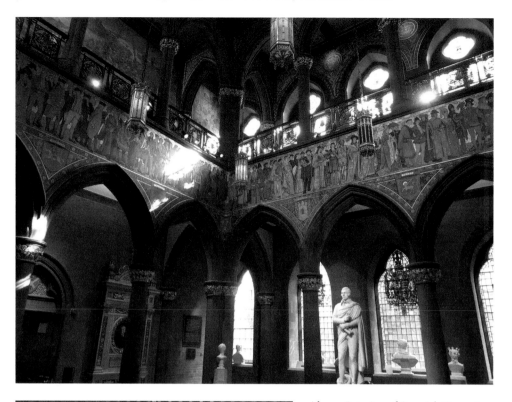

Above: Interior of Scottish Portrait Gallery.

Left: Royal College of Physicians, Queen Street.

Antiquarian, botanist and physician, Robert Sibbald became the first Professor of Medicine at the University of Edinburgh. He was appointed Geographer Royal, helped found the Royal College of Physicians and created a physic garden near Holyrood Abbey, which eventually became the Royal Botanic Gardens (see Botanic Gardens).

Fun Fact The Blue Whale was originally named *Balaenoptera Sibbaldus* after Sibbald, which impresses the hell out of me. Shame it was later changed to *Balaenoptera Musculus*. There's still a wild rose called *Sibbaldia Procumbens*, but that's a bit of a demotion from the largest mammal on the planet.

No. 28 House of John Harden (1772–1847) and his wife, Janet 'Jessy' Allan (1776–1837). Jessy's diary and her husband's drawings provide, probably, the fullest account of everyday society in the nineteenth-century New Town – basically, a lot of dancing at assembly rooms, politely singing round the piano and walks in the bracing air. And drinking, of course. Fittingly, it is now the headquarters of the Scottish Malt Whisky Society, which has a rather nice restaurant and a superb selection of the 'Amber Nectar'.

No. 46 House of Sydney Smith (1771–1845), wit, writer, Anglican cleric, co-founder of the *Edinburgh Review* and all-round oddball.

Scottish Malt Whisky Society, Queen Street.

Fun Fact Smith wrote a rhyming recipe for salad dressing, which was included in *Common Sense in the Household* by Marion Harland (1830–1922). This became one of the most successful American cookbooks of all time, selling over 10 million copies.
No. 52 Home to brilliant scientist and obstetrician James Young Simpson (1811–70), it was a magnet for scholars and scientists.

> The man who helped popularise midwives and develop the use of anaesthetics, James Young Simpson and his assistants conducted famous experiments on the effects of chloroform in his house – don't try this at home. Of his research, Simpson dryly noted: 'Before sitting down to supper we all inhaled the fluid and were all under the mahogany in a trice, to my wife's consternation and alarm.' This makes me wish I'd known him, despite his being the inventor of the terrifyingly named 'Air Tractor', the earliest known vacuum extractor to assist childbirth. It didn't catch on. Neither did his avocation of anaesthesia during labour, until Queen Victoria used it. After that, it was all the rage.
>
> Simpson had other admirably impish qualities, including seating a Southern US slave owner next to a freed slave at dinner.

No. 62 Home of physicist Sir John Leslie (1766–1832), author of *An Experimental Inquiry into the Nature and Properties of Heat* and inventor of the differential thermometer. He was the first person to give a modern account of capillary action and to artificially produce ice, which is pleasingly random. In 1805 he was elected to the chair of mathematics at Edinburgh University, despite violent opposition at his being an atheist.

York Place

An eastern extension of Queen Street, most of York Place was built at the end of the eighteenth century. It is named after the king's second son, traditionally known as the Duke of York. In the main it's almost as impressive as Queen Street, though a couple of modern concrete buildings spoil the aesthetic. An obtrusive tramway in the middle of the road doesn't help.
Interest Rating 3/5
No. 22 The house of Lord Newton, who defended Jacobite prisoners at their trial in 1747. Like many legal bigwigs of the time (and everyone else, as we've established), he drank copiously. He was frequently known to down three bottles of claret after dinner, before dictating papers of more than sixty pages to his clerk. He would spend the night getting sloshed at the Crochallan Club until seven in the morning, sleep for two hours, and be seated on the bench at the usual hour – looking suitably dignified, if a little weary. The very definition of a functioning alcoholic.
No. 32 This contained the later studios of the famous painter, Sir Henry Raeburn (*see* Stockbridge). His most famous works are a portrait of Walter Scott and *The Reverend Robert Walker Skating on Duddingston Loch*, displayed in the National Gallery of

Scotland on the Mound. If a minister in a top hat skating with his arms folded doesn't make you smile, nothing will.

No. 36 Home of Major-General Edward Broughton. He was a veteran soldier in India and Lieutenant Governor of the island of St Helena where, at the age of fifty-one, he married the sixteen-year-old niece of his boss. Yikes. In 1894, the Pharmaceutical Society of Scotland moved in and is still there.

No. 38 In the 1830s, this was the residence of John Lizars (1792–1860), who learnt his trade as naval surgeon during the Napoleonic Wars. He became a famous anatomist and wrote *The Use and Abuse of Tobacco*, warning of its dangers. It was, of course, ignored. Ironically, he died of an overdose of laudanum and is buried in St Cuthbert's churchyard, at the west end of Princes Street Gardens.

No. 47 Residence of Alexander Naysmith (1758–1840), 'The Father of Scottish Landscape Painting.' Supposedly, he is the only artist to have painted an authentic picture of Robert Burns. His son also lived there and went on to design the steam hammer – which aptly demonstrates the Enlightenment's blending of art and practicality. A plaque on the wall commemorates them both.

No. 57 Home of Scottish architect Thomas Hamilton (1784–1858), one of the leading Greek revivalists in Scotland. His Edinburgh works include the Royal High School and Burns Monument on Calton Hill, the George IV Bridge and the Bedlam Theatre in the Old Town, the Dean Orphan Hospital (*see* Dean Gallery), the New Town's Royal College of Physicians, and the Scottish Political Martyrs' Monument in Old Calton Cemetery.

St Mary's Roman Catholic Cathedral This is the seat of the Archbishop of Saint Andrew's and Edinburgh and the mother church of Scots Catholicism. Designed by Scottish architect James Gillespie Graham (1776–1855) and opened in 1814, the cathedral has been enlarged and rebuilt many times. It is well worth going inside for a look.

Young Street/Hill Street

Named after their builders, these narrow, unimposing streets have unsavoury little lanes on either side. Young Street, however, is the site of the legendary Oxford Bar which was frequented by Scottish writers and artists since the nineteenth century including poet, dramatist and novelist Sydney Goodsir Smith (*see* Drummond Place). The 'Ox', as it is often known, is now famous as the favoured haunt of Ian Rankin (b. 1960), author of the multimillion-selling *Inspector Rebus* novels.

Interest Rating 3/5

Fun Fact Hill Street was home to a pair of con men calling themselves Charles Edward Stuart and John Sobieski Stuart. As well as being the authors of a highly dubious book on Scottish tartans and clan dress, they caused controversy by claiming to be the grandsons of Bonnie Prince Charlie. In reality, they were John and Charles Allen, born in Wales.

No. 1 Home of James Ballantyne (1772–1833), Sir Walter Scott's printer, editor, literary agent and financial partner. When he went bankrupt, Scott did too.

Nos 17–19 Originally the Subscription Baths and Drawing House, this now houses the Edinburgh Masonic Lodge No. 1.

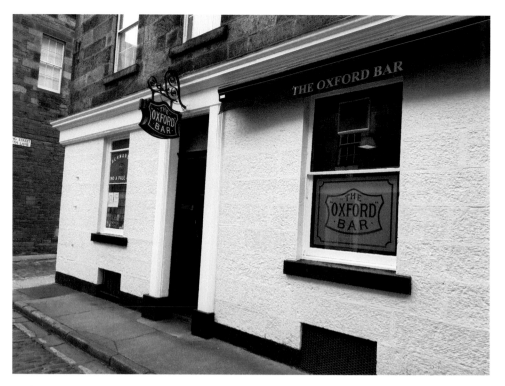

Oxford Bar, Young Street.

Fun Fact Moved from the Old Town, the building possesses recorded minutes from July 1599. This makes it, quite possibly, the oldest Masonic lodge in the world.

Thistle Street
Several of the original buildings have been replaced by ugly modern office blocks, and the lanes on either side are even nastier. Thistle Street, however, is the site of Thistle Court (formerly Rose Court). It was here that developer James Young received £20 from the council as an incentive for buying the first plot of land in the New Town. In 1768, he completed his residence. Completely ignoring the original plan to build a terrace, he created two houses facing each other across a courtyard. Both still exist.
Interest Rating 2/5

Castle Street and North Castle Street
So called for their proximity to the fortress, feuing of sites began here in 1792. Originally residential tenements, Castle Street is almost entirely shopfronts, though some of the buildings are still notable for their distinctive bow fronts. It is now pedestrianized and features occasional markets, but North Castle Street is considerably prettier.
Interest Rating 3/5 (4/5 when a market is on.)
No. 16 This was the house of Skene of Rubislaw, the bosom friend of Sir Walter Scott. He possessed the Bible used by Charles I on the scaffold, which, you have to admit, is a pretty cool souvenir.

No. 39 Sir Walter Scott lived in this house until he went bankrupt and was forced to move to Shandwick Place (*see* Shandwick Place). Fortunately he'd put his stately Borders home, Abbotsford House, in his son's name, so he eventually relocated there.
No. 30 Birthplace of Kenneth Graham (1859–1932), author of *The Wind in the Willows*. He based its most famous character, bumbling 'Mr Toad', on his son, Alastair, who later committed suicide. I'm sure there's a lesson be learned there for all writers.

Hanover Street
Built between 1784 and 1790 and named, unsurprisingly, for the Hanoverian dynasty, most of the tenements have been altered and redeveloped into shops, businesses and restaurants. The street leads south from Princes Street to the leafy but short Queen Street Gardens West.
Interest Rating 3/5
Fun Fact A golden pillar box, at the junction with Princes Street, commemorates Edinburgh cyclist Sir Chris Hoy. He holds a total of seven Olympic medals – six gold and one silver.
No. 35 Milne's Bar Built in 1790, this reflects the varied fortunes of a typical Georgian house. It belonged to an advocate, then an accountant, housed a dressmakers, a chiropodists and Lomond and Mills wine merchants, before becoming Milne's Pub in the 1950s. It is famous as the haunt of literary giants Hugh MacDiarmid (1892–1978), Sydney Goodsir Smith (1915–75), Sorley MacLean (1911–96) and Norman MacCaig (1910–96). These very different men engaged in lively political and poetic debate in a room hailed as the 'Little Kremlin', which is still part of the bar.
Fun Fact MacDiarmid was a founding member of the National Party of Scotland (now the SNP) and stood as a candidate for the Communist Party of Great Britain. MacLean

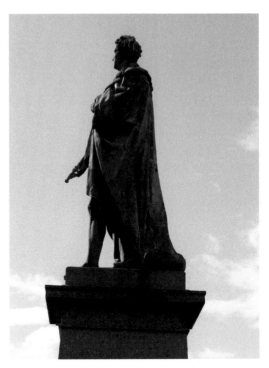
Statue of George IV, Hanover Street.

served in North Africa during the Second World War and was severely wounded during the Battle of El Alamein.

Statue of George IV Erected to commemorate the monarch's visit to Edinburgh in 1822. He looks quite regal, despite the fact that he was a great deal fatter than his effigy. The statue is much mocked by locals because of the positioning of George's sword hilt – from a certain angle, it looks like he is holding a part of his anatomy that should not be on display to traffic.

George IV was the eldest son of George III and Queen Charlotte. The Hanoverian kings were notorious for having bad relations with their heirs, and George was despised by his dad because of his dissolute lifestyle and a secret and illegal marriage to Roman Catholic Maria Fitzherbert. In 1795, he was officially married to Princess Caroline of Brunswick, in exchange for parliament paying his debts. She didn't like him either.

In 1811, George became regent after his father was declared insane and was crowned in 1820. His visit to Scotland in 1822, organised by Walter Scott, was the first by a British monarch in almost two centuries. Edinburgh put on an enormous celebration for him. Scott invited the northern clans to parade, in hastily invented highland dress, before the man whose family wiped them out at Culloden. Fake though it all was, it marked a turning point in highland/lowland relationships. From that point, the highlanders were romanticised as proud and noble warriors, rather than denigrated as savage, backward-looking irritants.

Henderson's Vegetarian and Vegan Restaurant An Edinburgh institution, opened in 1962 as an outlet for the produce of the husband and wife team who ran Mac and Janet's East Lothian Farm. The trifle is my favourite, even if there's no meat in it.

Fredrick Street
Named after King George III's father, Fredrick Prince of Wales and built between 1786 and 1792, many of the original buildings are intact, though you can't escape the smattering of shopfronts that permeate the original New Town.
Interest Rating 3/5
No. 36 The poet Percy Shelly and his second wife, Mary, stayed here for a while.

Hope Street
A short road with some nice bars, especially Whigham's Wine Cellars, incorporating early nineteenth-century cellars, which make for cosy alcoves. Running off it is Hope Street Lane, which has absolutely nothing to recommend it, unless you're a connoisseur of fire exits and wheelie bins.
Interest Rating 2/5
Haunted Rating 2/5 Hope Street is haunted by a woman called Moira Blair – though, apparently, only in the evenings.

THE SECOND OR NORTHERN NEW TOWN

Despite a slow start, the first phase of the New Town had been an unqualified triumph. So, in 1802, architects Robert Reid and William Sibbald produced plans for a second New Town. These had to take into account the fact that the terrain was much hillier but, once again, a grid pattern was adopted. Entire streets were built as one construction, in a much grander style of architecture than the original New Town. The principal thoroughfares were interwoven with more modest ones, containing smaller town houses and lanes lined with mews stables and service accommodation. Unlike the First New Town, the Second New Town looks pretty much the same as when it was built.

Heriot Row

Heriot Row dates from the early 1800s, the first street to be built in the Northern New Town, with houses looking south over Queen Street Gardens. Fanlights, decorative ironwork and ornate lamp posts make it one of the most striking New Town roads. And it has a pretty impressive list of occupants, a few of which are listed below.

Interest Rating 5/5

Haunted Rating 4/5 Recent residents of houses in the street have reported ghostly noises, beginning in 1981. One set of new occupants noticed that the shutters on the windows of their house kept opening, even though nobody was near them. Exploring the premises, they came across a secret compartment and, when they opened it, eerie sounds echoed through the building. You think the surveyor might have mentioned that.

No. 1 The house of Peter Spalding, Superintendent of the Calcutta Mint.

No. 2 Home of Cecil Aylmer Cameron (1883–1924). Despite being convicted of fraud, he became a First Word War spymaster, running agents in occupied France and Belgium. Awarded the Legion d'Honneur de France, Croix de Chevalier, and the Belgian Ordre de Leopold, he was eventually appointed Commander of the Order of the British Empire. Yet he couldn't escape the scandal of his tainted past, so resigned his commission then shot himself.

No. 6 Residence of Henry Mackenzie (1745–1831), author of *The Man of Feeling*, who championed Walter Scott, Robert Burns and Lord Byron. He is buried in Greyfriars Kirkyard in the Old Town.

No. 10 Home of Sir Byron Bramwell (1847–1931), a renowned brain surgeon and artist who published over 150 influential medical works. He is buried in Dean Cemetery, close to his eminent university tutor, Sir John Goodsir (1814–67).

Robert Louis
Stevenson's House,
Heriot Row.

No. 17 The house where Robert Louis Stevenson (1850–94) grew up. A sickly child and unwilling student, he spent many hours in the top-floor garret writing. Outside his house is the lamp post on which he based his famous poem *The Lamplighter*.
Fun Fact In Queen Street Gardens is a small lake, reconstructed from a farmer's cattle pond where the boy sailed paper boats. It is thought to be the inspiration for *Treasure Island*.

Stevenson was a man who knew what he wanted and set out to get it. Enrolled in Edinburgh University to study engineering then law, he showed no interest whatsoever in either course, preferring to go carousing on the Royal Mile. He grew his hair long, dressed like a bohemian, composed music, declared himself an atheist and dedicated his life to writing, to the horror of his Presbyterian father.

It paid off. He eventually became a sensation, publishing masterpieces like *Treasure Island, Kidnapped, A Child's Garden of Verses* and *The Strange Case of Dr Jekyll and Mr Hyde*. Dismissed in later years as a children's writer and horror novelist, he has finally regained his rightful place as a giant of British literature.

Dogged by ill health throughout his life, he searched for a more hospitable climate, finally settling on Samoa. In 1894 he died there of a probable brain haemorrhage. He was forty-four.

No. 30 Home of Ethel Maud Miller (1876–1946), a spiritualist who founded the Edinburgh Psychic College, later the College of Parapsychology, in 1932 (*see* Melville Street). The famous Scottish medium Helen Duncan (1897–1956) frequently gave talks and demonstrations in the house. Surprisingly, there are no recent reports of ghostly activity. However, since many of the attendees claimed to have seen or even communicated with the dead, it adds to the streets haunted rating. Who am I to be sceptical?

Victoria Helen McCrae Duncan, mother of six turned medium in 1926, offered séances in which she summoned spirits by emitting ectoplasm from her mouth. The sessions were captured in a series of famous photographs but the ectoplasm was later found to be made of regurgitated cheesecloth and lavatory paper mixed with egg whites. Despite being caught out on several other ruses, her reputation wasn't much dented. When she announced that the HMS *Barnum* had been sunk in 1941, before it became public knowledge, she was convicted under Section 4 of the Witchcraft Act of 1735. Possibly the last person to be imprisoned for the crime, it prompted Prime Minister Winston Churchill to lambast this misuse of court resources as 'obsolete tomfoolery'. The Witchcraft Act was subsequently abolished.

No. 31 Home of James Clerk Maxwell (1831–79). Einstein said his work was 'the most profound and the most fruitful that physics has experienced since the time of Newton' (see India Street). Also the birthplace of Jemima Blackburn (1823–1909), who attended the hanging of the serial murderer William Burke. She later wrote drolly, 'I remember my teacher offering me a present of a piece of (Burke's) skin as I had done my lessons well. I declined it with thanks.'

No. 41 Residence of the ultra musical Mackenzie family, whose exploits were recounted in the memoirs of their friend Rebecca West (1892–1983). She had plenty to write about; for example, their son Joey became mixed up in scandal after an incident in a gay brothel where a society figure was badly injured. Though he had only gone there to sing, his mother sent the lad to Canada to avoid any shame, where he died after being run over by a horse and cart.

Dame Cicely Isabel Fairfield, or Rebecca West, was educated in Edinburgh. Described by *Time Magazine* in 1940 as 'indisputably the world's number one woman writer', she reported on the Nuremberg trials and wrote several novels, including the acclaimed *The Return of the Soldier*. She had a son with HG Wells (1866–1946) and affairs with Charlie Chaplin (1889–1977) and Lord Beaverbrook (1879–1964). She is also responsible for one of my favourite quotes: 'People call me a feminist whenever I express sentiments that differentiate me from a doormat or a prostitute.' Well put.

Abercromby Place

Designed by Robert Reid in 1805, this extension of Heriot Row was the first curved street in Edinburgh. A radical departure from the normal New Town straight lines, people used to congregate just to stare at how odd it was. It is named after Sir Ralph Abercromby (1734–1801), Governor of Trinidad and hero of the Seven Years' War and Napoleonic Wars. He also fought in South America and took part in the Anglo-Russian invasion of Holland.

Interest Rating 4/5

No. 17 Home of William Playfair, who designed the National Gallery of Scotland and the Royal Scottish Academy. What he thought of the curved street is not recorded.

No. 25 Sticking to the architectural theme, this was the home of Robert Matheson (1808–77), a master of the Italian Renaissance style (*see* Grosvenor Crescent). He is buried in Dean Cemetery.

William Henry Playfair was one of the most influential architects of the nineteenth century. Son of the Scottish architect James Playfair and nephew of William Playfair (*see* Albany Street), he moved to Edinburgh as a boy. As well as the Mound Galleries, he is responsible for the City Observatory, the National Monument and memorials to Professor John Playfair (another uncle) and Dugald Stewart (all on Calton Hill), the University of Edinburgh Old College (begun by Robert Adam), George Heriot's Hospital, New College, the Advocates' Library, the Royal College of Surgeons (all in the Old Town), No. 105 George Street, Donaldson's Hospital, St Stephen's Church, Regent Terrace, Royal Terrace and Calton Terrace (all in the New Town). Impressive, huh? And that's just the stuff he built in Edinburgh.

Albany Street

Wide, peaceful and uniform, the first lots were fued out in 1801.

No. 2 This was the residence of William Playfair's uncle, John Playfair (1748–1819), Professor of Mathematics then Natural Philosophy at the University of Edinburgh and co-founder of the Royal Society of Edinburgh. In 1802 Playfair published his celebrated volume *Illustrations of the Huttonian Theory of the Earth*, which popularised the work of Edinburgh's James Hutton (1726–97), now known as 'the Father of Modern Geology'.

Playfair was, at various times, a millwright, engineer, draftsman, accountant, inventor, silversmith, merchant, investment broker, economist, statistician, pamphleteer, translator, publicist, land speculator, banker, editor and journalist. He served as a secret agent for Great Britain during its war with France, took part in the storming of the Bastille and organized a counterfeiting operation to try and collapse the French currency. He was also the founder of graphical methods of statistics and invented the pie chart. And he's not even the most famous one in his family.

No. 34 Home of the Scottish architect James Gillespie Graham, who built St Mary's Roman Catholic Cathedral and the spectacular Highland Tolbooth Church in the Old Town. He is buried in the Covenanter's Prison in Greyfriars Kirkyard.

Interest Rating 3/5

Northumberland Street

Completed in the 1820s, the composer, writer, editor and critic George Hogarth (1783–1870) lived here, where he was visited by his famous son-in-law, Charles Dickens. Running off it is similar but smaller Nelson Street.

Interest Rating 3/5

No. 15 This was the building where, in 1874, Sveinbjörn Sveinbjörnsson and Matthías Jochumsson wrote the Icelandic national anthem 'Ó Guð vors Lands'. Listen to it on Spotify; it's a lot better than God Save the Queen.

No. 25 Home to Walter Scott's son-in-law and biographer John Gibson Lockhart (1794–1854). A plaque on the wall commemorates him.

Barony Street

Constructed in the 1820s, this lane commemorates the old Barony of Broughton (*see* Broughton Street), whose village centre survived until the 1930s. Sadly, it's a bit dull these days.

Interest Rating 2/5

Great King Street

Named after, you guessed it, George III. This was the principle street of the northern New Town, wide and stately, with several notable residents.

Fun Fact Look out for granite setts in the pavement, stone blocks that enabled the residents to climb into Sedan chairs or carriages without getting their feet dirty from the gutters.

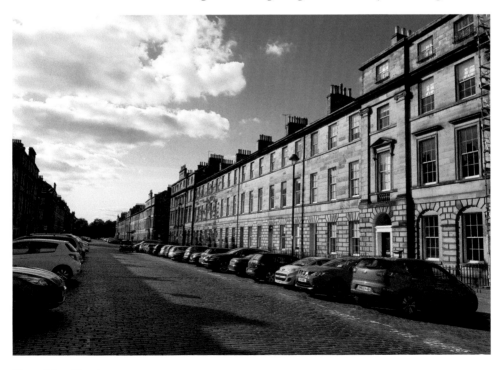

Great King Street.

Interest Rating 5/5

No. 3 House of Sir Robert Christison (1797–1882). Twice president of the Royal College of Physicians, he gave medical evidence at the trial of notorious mass killers William Burke and William Hare. J. M. Barrie (1860–1937), author of *Peter Pan*, lodged here when he was a young journalist.

No. 9 Thomas de Quincey (1785–1859), author of *Confessions of an Opium Eater*, lived here from 1830 to 1835. His work influenced Edgar Allan Poe, Fitz Hugh Ludlow, Charles Baudelaire, Nikolai Gogol and Jorge Luis Borges.

No. 12 Home of Thomas Hamilton (1789–1842), a former soldier and writer. He is better known as Cyril Thornton, after the title of his most famous book, considered one of the best military novels ever written.

No. 62 Former home of the writer Jan-Andrew Henderson. Sorry. Had to put that in. I lived at 10A as well, if anyone's interested.

No. 72 Residence of the painter Sir William Allan (1782–1850), who witnessed the French invasion of Russia and later became president of the Royal Scottish Academy. He is buried in Dean Cemetery.

No. 84 Home of Polish-Lithuanian composer and musician Felix Janiewicz (1762–1848). After performing across Europe (where he met Haydn and Mozart), he left Paris just in time to avoid the French Revolution. In 1813, he helped found the Royal Philharmonic Society in London, before moving to Edinburgh.

Drummond Place

At the east end of Great King Street and named for Sir George Drummond, this is a truly elegant and tranquil cobbled street. In the centre of what is now Drummond Place Gardens stood a country house belonging to the Lord Provost himself.

Drummond Place.

Interest Rating 5/5

Fun Fact In the garden you can still see original iron clothes poles for hanging out washing.

A former accountant, George Drummond held the post of Lord Provost six times, was a founding director of the Royal Bank of Scotland, a Presbyterian church elder and Grand Master Mason of the Freemason Grand Lodge of Scotland. He raised funds to build the Royal Infirmary, commissioned the Royal Exchange (which became the City Chambers) and established five chairs of medicine at Edinburgh University.

As if these achievements weren't enough, Drummond will always be remembered as the driving force behind the New Town. He instigated the draining of the Nor' Loch and laid the foundation stone for the North Bridge, in preparation for the new development, though he didn't live long enough to see much of it built. He is buried in the Old Town's Canongate Kirkyard.

Fun Fact Drummond was a staunch opponent of the Jacobites and their attempts to put a Stewart king back on the throne. He fought at the Battle of Sheriffmuir in 1715 and raised a company of volunteers to defend Edinburgh against Bonnie Prince Charlie in 1745.

No. 4 Home of the artist William MacTaggart (1903–81). He was president of the Royal Scottish Academy and grandson of William MacTaggart (1835–1910), the leading Scottish landscape painter of his time and a huge influence on his grandson. MacTaggart was one of the 'Edinburgh School', a group of twentieth-century local artists whose work is characterised by virtuoso displays in the use of paint, with vivid and non-naturalistic colour and themes.

No. 25 Residence of Sydney Goodsir Smith. A bronze plaque, bearing his profile, is fixed to the wall.

Sydney Goodsir Smith was the Art Critic for *The Scotsman* newspaper, journalist, broadcaster, writer and poet. Born in New Zealand and educated in England, he suddenly adopted a Scots vernacular and used it like a master. Known as 'The Kilted Kiwi' or 'The Auk', Smith became one of the leading lights of the thriving Scottish literary scene in the 1950s and 1960s, centred in Edinburgh. His most famous work is *Under the Eildon Tree* and this is a short excerpt:

> *I was the potent prince o' ballatrie,*
> *My lyre opened portes whareer I thocht to gang,*
> *My fleean sangs mair ramsh nor wine*
> Yeah. I don't understand it either.

He died after a heart attack outside a newsagents on Dundas Street and is buried in Dean Cemetery.

Nos 31 and 32 Home of Sir Compton McKenzie (1883–1972), author of *Monarch of the Glen*, which was turned into an immensely popular BBC TV series. He then wrote *Whisky Galore*, which was made into a superb 1949 film and a mediocre 2016 one. He was also an actor, soldier, government spy, political activist, journalist, cultural commentator, snooker enthusiast, raconteur and a co-founder of the National Party of Scotland – forerunner of the SNP. I presume he slept at some point.

Cumberland Street and Lane

Cumberland Street is named for King George III's brother, the Duke of Cumberland. He decimated Bonnie Prince Charlie's highland army at the Battle of Culloden in 1746, then encouraged his men to burn, pillage, rape and murder. The street was planned by architects Robert Reid and William Sibbald, with cheaper housing for well-off tradesmen. Just off it is a tranquil lane that most visitors never see.
Interest Rating 3/5
The Cumberland Bar Once known as 'The Tilted Wig', it was a frequent lunchtime and evening stop for the area's lawyers, judges and other professional inhabitants. It was immortalised in Alexander McCall Smith's (b. 1948) serialised novel *44 Scotland Street,* as a typical New Town drinking establishment. It has a cool beer garden too.

Zimbabwe-born Alexander McCall Smith was emeritus professor of medical law at the University of Edinburgh and expert on bioethics. He is an amateur bassoonist and co-founder of the wonderfully titled 'Really Terrible Orchestra', set up for people without the talent or experience to be in a professional body. He is also the bestselling author of over forty million books, translated into almost fifty languages, the most famous of which is *The No. 1 Ladies' Detective Agency* series. His celebrated *44 Scotland Street* books (*see* Scotland Street) paints a vivid portrait of life in the modern New Town.

Fun Fact Smith helped found Botswana's first centre for opera training and wrote the libretto for their premiere, a version of *Macbeth* set among a troop of baboons.

Fettes Row and Royal Crescent

An elegant duo of serene, leafy roads that lead to Scotland Street. They look down on King George V and Scotland Street Park, formerly Canonmills Loch, which serviced local mills until it was drained in 1847. The parks contain the entrance to the Scotland Street Tunnel (*see* Scotland Street).
Interest Rating 3/5

Royal Crescent from Sunnyside.

Circus Place and Royal Circus

At the end of Great King Street, this was once a small farm. Circus Place is the main road, mostly bordered by greenery rather than houses. Royal Circus was designed by William Playfair in 1822 and forms a ring around it. Away from the traffic, the sense of peace and quiet on this smaller road is almost palpable.

Interest rating 4/5

Fun Fact There used to be a second-hand clothing shop called Madame Doubtfire's on the corner of South East Circus Place, and Madame Doubtfire would often sit outside. The author Anne Fine (b. 1947) used to pass by and the name stuck in her mind. The result was her novel *Madame Doubtfire*, later turned into the movie *Mrs Doubtfire*, starring Robin Williams.

Haunted Rating 2/5 A spectral woman kept appearing in the buildings being renovated here, upsetting workmen so much that they called in a medium to investigate. After the medium 'made contact', the young woman was never seen again.

No. 24 Residence of Sir Henry Duncan Littlejohn (1828–1914) with a plaque outside commemorating him.

Royal Circus.

At one time or other, Henry Littlejohn was Police Surgeon for Edinburgh, Medical Officer for Health, Head of Edinburgh University's Chair of Forensic Medicine, lecturer in medical jurisprudence at the Royal College of Surgeons of Edinburgh and Commissioner of the Board of Supervision, which oversaw the city's sanitary conditions. This was definitely a man who ate lunch at his desk.

In 1865, he published his devastating *Report on the Sanitary Conditions of the City of Edinburgh*, which outlined depravation and poverty in the Old Town. This led to almost two-thirds of the Royal Mile being demolished by 1900. Littlejohn was also cited by Arthur Conan Doyle as one of the inspirations for Sherlock Holmes.

Jamaica Street and Lanes

Built between 1807 and 1819, this was the only substantial development of workers' houses in the Northern New Town. It was almost totally demolished in 1960 and is now an uneasy mixture of old and modern structures.

Interest Rating 2/5

No. 39 Kay's Bar Originally a Georgian coach house, John Kay and Sons remodelled it in early Victorian times and sold wine and spirits there for 150 years. In the 1970s it was remodelled again and turned into a public house. It retains many of its Victorian features, such as the bar, internal signs, barrels, pillars and fittings.

Haunted Rating 2/5 The street was stalked in the late eighteenth and early nineteenth centuries by a man in a bright red hat. His appearance even caused a court case, when the landlord accused his tenant, James Campbell, of inventing the spectre to keep his

Kay's Bar, Jamaica Street.

rent down. Despite the fact that Campbell produced witnesses to back up his story, he was fined £5 and told not to mention the ghost again.

Gloucester Place and Doune Terrace
Tucked away between Stockbridge and the former Moray Estate (*see* Moray Estate), these little-explored roads epitomise the tranquillity of the Northern New Town. It's not unusual to walk the length of both streets and never see another person.
Interest Rating 3/5

India Street
Built in the early nineteenth century, this secluded street is not to be confused with India Place, a little further on.
Interest Rating 3/5
Haunted Rating 3/5 No. 56 was haunted by a frequently seen entity floating in the hall, but so shadowy it couldn't be identified as a man or woman. It only turned up for dinner parties or social occasions, which makes it a typical New Town resident.
No. 14 Birthplace of James Clerk Maxwell, a scientific colossus who never got the recognition he deserved. It is now the site of the James Clerk Maxwell Foundation.

India Street.

When Albert Einstein was asked if he had stood on the shoulders of Newton, he replied, 'No, I stand on Maxwell's shoulders.' Einstein also claimed his Special Theory of Relativity owed its origins to Maxwell's equations.

One of the all-time scientific greats, shamefully, he is not particularly famous. But this 'Father of Modern Physics' came up with the one of the most significant discoveries of all time: the theory of electromagnetism. He proved that light is an electromagnetic wave and so linked electricity, magnetism and optics, pointing the way to the existence of the spectrum of electromagnetic radiation. His kinetic theory of gases explained the origin of temperature. His work laid the foundation for quantum theory. He was the first person ever to produce a colour photograph. He used mathematics to explain Saturn's rings, over a century before the *Voyager* probe confirmed his findings. And he wrote poetry. What a guy.

Howe Street

Named after Richard Earl Howe (1726–99), a naval officer who served in the War of the Austrian Succession, the Seven Years' War, the American Revolutionary War, the Siege of Gibraltar and the French Revolutionary Wars. He must have had skin like armour.

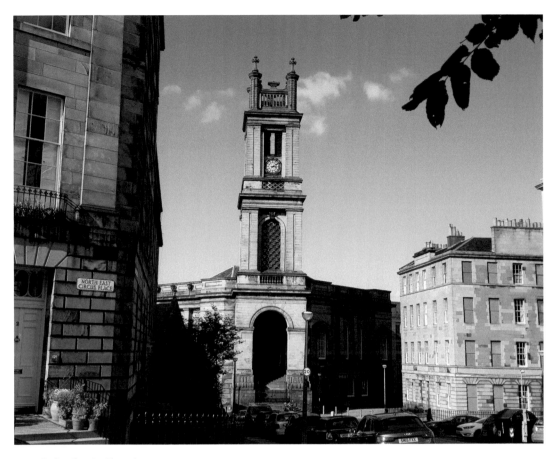

St Stephen's Church.

Interest Rating 3/5
No. 11 Once the home of John Ewebank (1799–1847). Famous in his time as a marine and landscape painter, a lapse into alcoholism meant he died in poverty and obscurity.
St Stephen's Church Built by William Playfair in 1827, it is at the end of St Vincent Street, an extension of Howe Street. This square Grecian building, with baroque flourishes and an octagonal interior, has a daunting set of steps leading up to the entrance – to compensate for the steep slope it's built on.

Dundas Street
Formerly Pitt Street, this steeply sloping extension of Hanover Street was begun in 1807 and named after Henry Dundas (he of the large plinth in St Andrews Square). Lined with huge tenements, it also has quite a few bricked-up windows, some of which were sealed to avoid the 'window tax' of 1748.

Dundas Street now has an excellent collection of antique stores and private art galleries, as well as a view that stretches right over the Firth of Forth to Fife. Note my excellent use of alliteration there.
Interest Rating 4/5

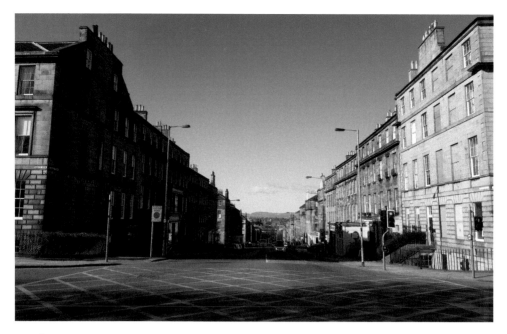

Dundas Street.

Scotland Street

Begun in 1823, and formerly known as Caledonia Street, the most famous parts of Scotland Street can't actually be seen. In the 1840s the Edinburgh, Leith and Newhaven Railway built a tunnel under the New Town to link Scotland Street with Canal Street Station (later absorbed into Waverley Station). It went through three quarters of a mile of solid igneous rock on an incredibly steep gradient, cost a fortune and required huge

Rodney Street Tunnel.

amounts of effort. But this is Edinburgh, so the line was abandoned in 1868. Since then, the tunnel has been used to grow mushrooms, as an air-raid shelter, the site of natural radiation experiments and a car park. Naturally, such a unique spot is now abandoned. Shame. I reckon it would make a great underground ski slope.

Interest Rating 4/5

Fun Fact Opposite the Scotland Street Tunnel is the less imposing Rodney Street Tunnel. Opened in 1847 and closed in 1968, it is now part of a cycle path.

No. 44 The setting for the famous series of 44 *Scotland Street* novels by Alexander McCall Smith. But there's no point in looking for it, because the doors stop at No. 43.

Broughton Street

Broughton was once a separate burgh, standing on a 1,000-year-old road from Edinburgh to Leith. The first Georgian houses were built in 1808, replacing thatched cottages, and it is now one of the most bohemian streets in the city, filled with bars and speciality shops.

Interest Rating 4/5 (For its vibrancy, not its look)

Nos 81–85, Barony Bar A wine and spirits merchant since 1896, it became a licensed pub under William Younger and Co. in 1955. Its fine internal features include an L-shaped bar, splendid tile work, detailed cornices and whisky mirrors.

Barony Bar, Broughton Street.

Fun Fact The bar was one of the settings for Sylvain Chomet's delightful 2010 animated film *The Illusionist*, written by the renowned French mime Jacques Tati (1907–82).

Mansfield Place and Bellevue Crescent

The crescent, an extension of Mansfield Place, was designed in 1818 and is the site of the gloomily neoclassical St Mary's Church, with a 168-foot spire. Across the street is a set of tenements that give an indication of how grand the area once looked. The rest of the place is a bit of a mishmash, as are all the fringes of the Northern New Town.
Interest Rating 3/5

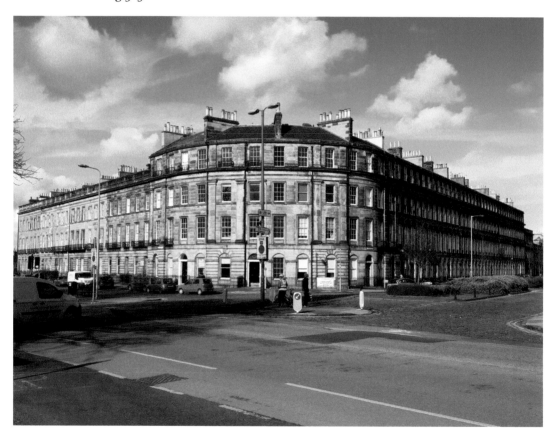

Bellevue Terrace.

THE EASTERN EXPANSION (PICARDY AND GAYFIELD)

The New Town's eastern expansion has suffered from the ravages of modernisation more severely than other areas. Many of the Georgian tenements and houses have been demolished, but there are still plenty of nooks, crannies and side lanes worth exploring.

Picardy Place

Once the village of Picardy, which became home to a group of skilled weavers from the Picardie region of north-east France. The Picardy Place extension was mostly finished by 1809, and in 1191 a statue of Sherlock Holmes was erected to celebrate Edinburgh-born author Sir Arthur Conan Doyle (1859–1930), who was born at No. 11. His house has now been replaced by a traffic roundabout but he has a pub named after him at the top of Broughton Street.

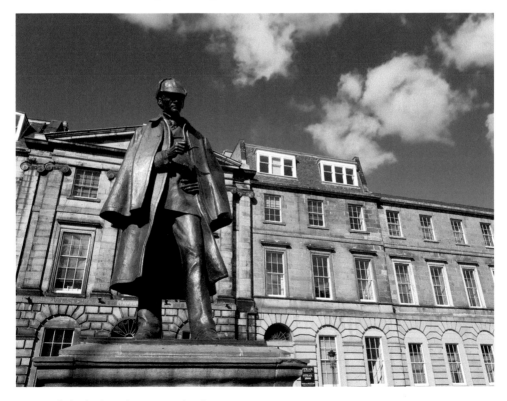

Statue of Sherlock Holmes, Picardy Place.

Interest Rating 3/5

Fun Fact If you climb onto the statue's plinth and follow the detective's gaze downwards, you can see what he's looking at. It's the footprint of a large hound.

Haunted Rating 2/5 Picardy was one of the sites where women found guilty of witchcraft were burned. It was also where Major Thomas Weir, 'the Wizard of the West Bow', was executed for conspiring with the Devil. Look him up. It's quite a story but one that really belongs to the Old Town, where he lived. You can find it in *The Royal Mile: A Comprehensive Guide.*

East London Street

Originally the village of Broughton, which was almost a thousand years old when, in the late eighteenth century, it was replaced by New Town buildings. Though it has a couple of points of interest, this once dignified street is now an architectural disaster zone, filled with run-down tenements, garages and buy-to-let homes. It runs into London Street, which is much nicer and gives you a good idea of how East London Street looked in its heyday.

Interest Rating 2/5

No. 15 Birthplace of Norman MacCaig (*see* Hanover Street). One of Scotland's most influential poets, MacCaig was Edinburgh University's first Writer in Residence, from 1967 to 1969.

Phoebe Traquair Murals, Mansfield Traquair Centre, East London Street.

The Mansfield Traquair Centre Formerly the Catholic Apostolic Church, this neo-Romanesque building was designed by Sir Robert Rowand Anderson (1834–1921) and completed in 1885. It now houses the Scottish Council for Voluntary Organisations and features stunning murals by Phoebe Anna Traquair (1852–1936). Traquair was a central figure of the Arts and Crafts movement and, because of her work, the building was nicknamed 'Scotland's Sistine Chapel'.

Gayfield House Gayfield is a fine country villa, built in 1761. It has been a veterinary college, the house of a manure merchant (who stored his produce downstairs), a laundry and a garage. Eventually left derelict, it was saved by a former naval officer called Trevor Harding, who bought and restored it over many years.

Forth Street

Compact and mostly unchanged, this street is typical of the smaller back roads of the area. No. 10 was home to the eminent artist George Watson (1767–1837), first president of the Royal Scottish Academy and pupil of Sir Joshua Reynolds (1723–92). His son, William Smellie Watson, RSA (1796–1874), a distinguished portrait painter, also lived there.

Interest Rating 3/5

Other Streets Worth Looking At

Though the eastern expansion is tarnished and modernised, smaller thoroughfares off the main roads are still worth strolling along. These include Union Street, Broughton Place, East Broughton Place, Gayfield Street, Hopetoun Crescent, Hart Street and Gayfield Square.

Fun Fact Inspector Rebus, hero of the famous Iain Rankin novels, sometimes operated out of the police station in Gayfield Square. It's not much to look at though.

THE WESTERN EXPANSION
(THE MORAY ESTATE)

The Earl of Moray owned 13 acres of pastoral land north-west of Charlotte Square. Moray was shrewd enough to see that its proximity to the New Town had a great deal of money-making potential and, in 1822 began to fue it out. But he wanted the area turned into something special, so James Gillespie Graham drew up precise plans, insisting they be strictly adhered to. The result was three main spaces forming foliaged compartments, linking the original and Northern New Towns. Called by critics of the time as 'beautifully monotonous and magnificently dull', the street names all have connections with the Moray family and the area was popular with Scottish law lords and eminent physicians.

Moray Place
One of the grandest addresses in the city, with a series of town houses designed as a palace front surrounding an ornate and central enclosed pleasure ground. It is separated from the Northern New Town by Darnaway Street and, curving off from it is the equally impressive Doune Terrace. This would offer a great view of Stockbridge below, if a large cultivated hedge wasn't in the way.

Interest Rating 4/5

No. 6 John Learmonth moved here from Charlotte Square and stayed until his death. (*see* Charlotte Square and Dean Estate). He is buried in Greyfriars Kirkyard in the Covenanter's Prison.

Moray Place.

Nos 22–24 Home of Francis (Lord) Jeffrey (1773–1850). Scottish judge and literary critic, his house was filled with intellectuals and artists, discussing philosophy and matters of state, while getting raging drunk in the process. He was editor of the *Edinburgh Review*, the most radical publication of its age, and enlisted a dazzling array of contributors, including Walter Scott, Henry Brougham (*see* St Andrews Square) William Makepeace Thackery, William Hazlitt and John Stuart Mill.

Fun Fact In 1806, Jeffrey criticized the poetry of Thomas Moore (1779–1852) in his *Edinburgh Review*. This annoyed Moore so much, he insisted the two authors fight a duel. It was stopped by the police, fortunately for Jeffrey, who had neglected to put bullets in his pistol. Oddly enough, the men eventually became good friends.

No. 28 Residence of the Earl of Moray himself. The grandest house on the estate, with six large columns at its entrance, it sprawls over 11,000 square feet.

Wemyss Place

Named after the Earl of Moray's stepmother, Lady Margaret Wemyss, it was one of the few sections built with mews or stables.

Fun Fact The central block was headquarters to Edinburgh's Home Guard during the Second World War and painted in camouflage colours. This meant it completely stood out from the surrounding buildings, so they may as well have stuck a bulls-eye on top. It was only restored to natural stone in the late twentieth century.

Interest Rating 2/5

Forres Street

A short and steep street, opening south from Moray Place.

No. 3 This was the residence of Thomas Chalmers (1780–1847). He was the first moderator of the Free Church of Scotland and the man who instigated the Great Disruption of 1843, leading a walkout of 450 ministers from the Church of Scotland General Assembly (*see* George Street).

Interest Rating 2/5

Ainslie Place/Great Stuart Street

Ainslie Place is named after the Earl's wife, Margaret Jane Ainslie, and is an expansion of Great Stuart Street.

Interest Rating 4/5

No. 5 Home of Dugald Stewart (1753–1828), one of the leading figures of the Scottish Enlightenment.

Dugald Stewart was a brilliant polymath and gifted philosopher. Appointed Edinburgh University's Professor of Mathematics at the age of twenty-five, he was also Professor of Moral Philosophy. Stewart had a huge impact on the intellectual climate of the Western world, attracting students from England, Europe and America in numbers that had never been seen before, including two future prime ministers (Lord Palmerston and Lord Russell). He made Adam Smith famous by

giving lectures on his seminal book *The Wealth of Nations* and his contributions to linguistic theory are regarded as a turning point in the history of the subject. At the time of his death, Stewart's prestige was so high he was lamented as 'the pride and ornament of Scotland' and a monument was erected to him on Calton Hill. He is buried in Canongate Kirkyard in the Old Town.

No. 23 Home of the Very Revd Edward Bannerman Ramsay, known for his bestselling *Reminiscences of Scottish Life and Character*. In 1879 a memorial to his memory was erected at the west end of Princes Street, eastward of St John's Church.

No. 8 Great Stuart Street Home of David Bryce, one of Scotland's foremost architects who built several iconic Edinburgh landmarks. He is buried in New Calton Cemetery.

No. 17 Great Stuart Street This was also home to the famous architect William Henry Playfair (*see* Abercromby Steet). Ironically, the house wasn't his own design but built by his great rival, James Gillespie Graham. Playfair is buried in Lord's Row on the western wall of Dean Cemetery, where he designed a number of monuments, including one for Lord Jeffrey. Graham is buried in the Covenanter's Prison in Greyfriars Graveyard.

Lynedoch Place/Randolph Cliff

Lynedoch Place is named after General Thomas Graham, 1st Baron Lynedoch (1748–1843) who fought in the Peninsular War, the French Revolutionary Wars and the Napoleonic Wars. Although much of it is given over to retail properties, the street improves massively as it continues north-west to Belford Road. It also contains Randolph Cliff, a row of towering tenements perched precariously over a terrifying drop down to the Water of Leith.

Interest Rating 4/5

Randolph Cliff.

THE WESTERN NEW TOWN

The Western New Town comprises a grand series of crescents, streets and squares in various styles. Unlike the Northern New Town, it is built on flat land and many of the streets and landmarks are Victorian, though sticking to the original Georgian vision.

Queensferry Street

Built in the 1850s, on the site of a row of cottages called Kirkbraehead, Queensferry Street runs north-west from the tip of the original New Town, becoming Lynedoch Place, Randolph Place and finally Queensferry Road, leading to the Dean Estate (*see* Dean Estate).

Interest Rating 3/5

No. 1. H.P. Mather's Bar Established in 1903, this former bank building has a high ceiling, ornate plasterwork, stained-glass windows and rare brewery mirrors. A genuine Scottish, old-school, no frills pub. Doesn't even have a website.

H. P. Mather, Queensferry Street.

Rutland Street and Square

Designed by lesser-known architect John Tait (1787–1856) between 1830 and 1840. The street ends at a bustling square, home to several international consulates, including those of India, New Zealand and Norway. A couple of passageways provide entrance to Edinburgh's new financial district, a recent complex that is still worth checking out.

Interest Rating 4/5

The Waldorf Astoria Also known as the Caledonian, this railway hotel was built to rival the Balmoral at the other end of Princes Street. Though the west end station is long gone, the Caledonian remains one of the New Town's most iconic landmarks.

No. 23 Home of Dr John Brown (1810–82), author of *Rab and His Friends,* a doleful shaggy dog story about a misunderstood mastiff. Although immensely popular in its day, it didn't have the longevity to stand up against Edinburgh's Old Town literary pooch, Greyfriars Bobby.

Fun Fact Though based on a true story, *Greyfriars Bobby* was written by the American author Eleanor Atkinson, who never set foot in Edinburgh. Neither her book, nor the subsequent Disney movie, are particularly accurate.

Waldorf Astoria from Rutland Place.

Gladstone Memorial with Charlotte
Chapel in background.

Shandwick Place/Athol Place/Maitland Street

An extension of Princes Street, this multi-named thoroughfare was started in 1805 and
incorporates Coates Crescent and Athol Crescent, two small curved streets wrapped
around Coates Gardens.

Interest Rating 3/5

Gladstone Memorial An elaborate statue to four-times British Prime Minister William
Gladstone (1809–98), surrounded by allegorical figures representing his virtues. A bit
butt-kissy but striking, nevertheless.

No. 6 The last residence of Sir Walter Scott before he moved to the Borders.

Haymarket Terrace/West Coates

A bustling area at the end of the Western New Town, it doesn't look like much these
days, but has some fine monuments and buildings scattered along the way.

Interest Rating 3/5

Heart of Midlothian Clock This is a memorial to the First World War, built by
H. S. Gamley in 1921–22. It commemorates seven players of Edinburgh's Heart of
Midlothian football team who died fighting in the First World War. The entire squad
bravely signed up in 1914, which, sadly, proved to be a massive own goal.

Haymarket Train Station Dating from 1840, this was originally the head office and
terminus of the Edinburgh and Glasgow Railway. Relegated to a coal depot in the
nineteenth century, it is fully functioning again.

Donaldson's Hospital and School Sited in West Coates, this enormous structure was designed in 1851 by William Henry Playfair and inspired by Elizabethan manor houses. It was paid for by Sir James Donaldson (1751–1830), publisher of the *Edinburgh Advertiser* who allowed special bursaries for poor children, especially deaf ones. In 1938, the Royal Institute for the Deaf and Dumb took this altruism to its logical conclusion and merged with the school. By 2003 the building was converted into luxury residential accommodation.
Fun Fact Queen Victoria opened the building and is reputed to have said it was more impressive than many of her own palaces.

Grosvenor Crescent and Gardens and Landsdowne Crescent
These two crescents face each other, with gardens in between. Grosvenor Crescent, by John Chesser (1819–92), 'the prime exponent of terrace design', is the grander of the two, while Landsdowne Crescent was the work of Robert Matheson. It's very typical of the streets and crescents in this area.
Interest Rating 3/5

Melville Street and Crescent
Melville Street was designed by Robert Brown in 1814 and its development, along with the area north of Shandwick Place, was completed by 1825–6. At the centre is an 1857 bronze statue by Sir David Steele of Robert Dundas, the second Viscount Melville. Has a great view of St Mary's Cathedral (*see* Palmerstone Place).
Interest Rating 3/5
Fun Fact In 1826, Brown is reputed to have invented a machine for fighting fires in tall buildings. Not a bad idea with all those tenements around.
No. 36 Residence of Patrick Fraser Tytler (1791–1849), advocate, eminent historian and author of *History of Scotland*. Popular title, that. In 1816 he became King's Counsel to the Exchequer and is buried in the Covenanter's Prison in Greyfriars Graveyard.
No. 37 Home of Janet Story, whose memoirs depict West End high society in the 1830s. Her description of a typical dinner is rather mouth watering. They usually started with two soup and side dishes, followed by four starters, including a curry (a favourite of her father, who had served in India). This was followed by two joints of meat, with extra servings of duck and a ham or beefsteak pie. Dessert was a spun sugar and pastry case, fruit, pudding, vanilla and raspberry cream and a pale wine jelly. No McDonald's for this lot.

Chester Street
An extension of Drumsheugh Street, Chester Street was built mainly between 1862 and 1870 and runs parallel to Melville Street. It contains a blend of Georgian and Victorian styles by John Lessels (1809–83), who also designed much of Melville Crescent, Coates Place, West Maitland Street and Palmerston Place. He is buried in Dean Cemetery.
Interest Rating 3/5

Rothesay Terrace and Place
The northern tip of the Western extension, these were designed by Peddie and Kinnear, then John Watherston & Sons. They were named after the royal title 'the Duke of Rothesay', given in Scotland to the reigning monarch's elder son (currently Prince Charles).

Interest Rating 4/5

Haunted Rating 4/5 In 1958 the Van Horne family purchased some second-hand furniture belonging to a recently deceased sailor. Soon after, strange tapping sounds began, ornaments moved around, the smell of tobacco smoke drifted through the house and a bright ball of light was occasionally spotted. Eventually a tiny foot-high figure began to make appearances, dressed in a brown jacket and red trousers. The Van Hornes, without apparent concern for their own safety, gave him the ignominious nickname of Gnomey. The occurrences came to a halt in 1960.

In the relatively short time since, this legend has developed numerous variations. Some accounts say the ghost has the equally embarrassing moniker of Merry Jack Tar and haunts the flat because of an old piece of wood brought back from a seaside cottage in the north of Scotland.

No. 3 Home of John Ritchie Findlay (1824–98), much larger than its neighbours and built in a more flamboyant style.

Owner of the *Scotsman* Newspaper and a renowned philanthropist, John Ritchie Findlay paid for the Scottish National Portrait Gallery and was instrumental in achieving the admission of women to the University of Edinburgh Medical School. He was a champion of 'ideal' workers' housing and paid for Well Court in Dean Village (*see* Dean Village). He avoided political office and refused the offer of a baronetcy, but has a monument in Dean Cemetery, where he is buried in Lords Row.

No. 7 Built in 1891 for Andrew Graham Murray (1849–1942), Viscount and Lord Dunedin. He served as Secretary for Scotland, Lord Justice General and Lord President of the Court of Session. Dunedin died in 1942, with no surviving male heirs, so both his titles became extinct. I don't mind taking one.

Palmerstone Place

Running from Shandwick Place towards Dean Village, this is a busy main street which, nevertheless, contains some remarkable buildings. Also a good starting place if you want to explore the leafy streets running off on either side.

Interest Rating 4/5

No. 12 Palmerstone Place Church Modelled on Saint-Sulpice in Paris, this church dates from 1875 and features a fine Wells-Kennedy organ, installed in 1992.

St Mary's Episcopal Cathedral Designed in a Gothic style by George Gilbert Scott in 1879, it is the largest church built in Scotland since the Reformation. With the installation of the Hanoverian dynasty, Presbyterianism replaced Episcopacy, leaving the Episcopalians without a cathedral. So two spinsters called Barbara and Mary Walker put up the funds to construct one. Fittingly, their grandfather was George Drummond, initiator of the New Town.

No. 25 The Arthur Conan Doyle Centre The Centre was formed to provide for the physical, emotional and spiritual well-being of society and community needs in the city. It is also home to The Edinburgh Association of Spiritualists.

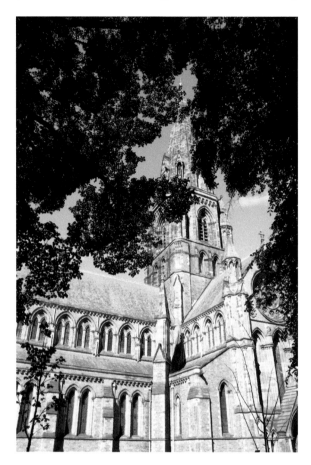

St Mary's Cathedral,
Palmerstone Place.

Fun Fact Holmes and Watson were originally to be called Sheridan Hope and Ormond Sacker.

Arthur Conan Doyle (see Picardy Place) will always be most famous for creating Sherlock Holmes, a character he bitterly blamed for the financial and critical failure of his more serious work. But Doyle was also fascinated by the paranormal, an allure that spiralled into obsession after he lost his son, brother, brothers-in-law and two nephews during the First World War. He championed the existence of fairies, became a spiritualist and travelled the world on 'psychic crusades'. A strange sort of behaviour for the creator of a character so driven by logic.

Other Streets to Check Out

This area has a warren of serene roads and lanes, so I recommend you simply wander around. Smaller streets like William Street, Alva Street, Grosvenor Street, Canning Street Lane, Stafford Street, Walker Street and Manor Place are all decent enough. But Randolph Crescent, Roseberry Crescent, Eglington Crescent, Glencairn Crescent, Douglas Crescent and Magdala Crescent are peacefully, unobtrusively spectacular.

THE EASTERN NEW TOWN

In 1813, Sir John Marjoribanks, then Lord Provost of Edinburgh, revived a scheme to build a jail on Calton Hill. In order to access this and shorten the road to England, he presented a plan to build Regent Bridge (*see* Regent Bridge).

This paved the way for construction of the Eastern New Town. Much of it was designed by William Henry Playfair, who intended to outshine James Craig's original. It started off promisingly but developments to the north were never properly completed and it is now a mixture of incredible Georgian splendour and modern renovations. Some are novel, like Greenside Place; others are hideous. But the bits worth seeing are *really* worth seeing.

St James Square/Leith Street/Greenside Place

From St James Square to George Street stood Gabriel's Road, an old lovers' lane, winding through corn fields. The New Town replaced the lane and was originally filled with typical Georgian houses. Between 1966 and 1972, however, Edinburgh embraced modern city planning – with the promise of a shiny future including such things as robots and jetpacks. Leith Street, St James Square and Greenside were annihilated and many of the dwellings replaced by concrete Brutalist structures, typified by the St James' Centre. This looked like it was constructed by a five-year-old playing with dented cereal packets and, thankfully, was demolished in 2018.

Demolition of St James Centre.

Greenside Place is the only interesting new development, built on an area that once boasted fairs and jousting tournaments, watched by Mary, Queen of Scots. The area's fine buildings eventually fell into disrepair and it was a slum by the twentieth century. It now has some eye-catching structures, like the Omni Centre and the Glasshouse Hotel, which incorporates the frontage of the 160-year-old Lady Glenorchy Church. This area is also known the 'Pink Triangle', a cluster of gay-friendly bars and nightclubs in Greenside, Broughton Street and Picardy Place.

Interest Rating 1/5 (Except Greenside, which is 3/5)

Haunted Rating 2/5 The original Theatre Royal (now demolished) seemed to be cursed, burning down then being rebuilt several times. Ghosts were supposed to have put on their plays there after it closed each night.

The Playhouse Theatre Originally envisaged as a variety theatre, it was eventually built in 1929 as 'Super Cinema' by the architect John Fairweather (1867–1942). Based on the Roxy Theatre in New York, it was visited by Laurel and Hardy, Marlene Dietrich and Yul Brynner, before closing in 1973. Thankfully, it was saved from demolition and opened again as a theatre and band venue in 1980.

Fun Fact The first film to be screened was *The Doctor's Secret*, an adaptation of J. M. Barrie's play *Half an Hour* (*see* Great King Street).

Haunted Rating 4/5 The Playhouse Theatre has a resident spectre, Albert, who first appeared in the 1950s. A grey-coated man, he appears on level six, bringing a sudden chill to the air. Albert is said to have been either a stagehand who died in an accident, or a nightwatchman who killed himself.

Theatre Bar, Greenside Place.

Calton Hill

This volcanic, gorse-covered hill has panoramic views of the city and is studded with monuments, the most impressive of which is William Playfair's National Monument of Scotland. Modelled on the Athens Parthenon, it was conceived in 1816 as a memorial to those killed during the Napoleonic Wars. But the city ran out of money and only the front was finished, leading it to be called 'Edinburgh's Shame'. There are also two observatories: Old Observatory House, designed by James Craig in 1792; and the City Observatory by William Playfair, built in 1818.

Interest Rating 5/5

Haunted Rating 2/5 Seventeenth-century lore tells of a gateway here to the fairy kingdom, which only those with second sight could see. A character called the Fairy Boy of Leith

Right: National Monument of Scotland.

Below: Dugald Stewart Monument, Calton Hill.

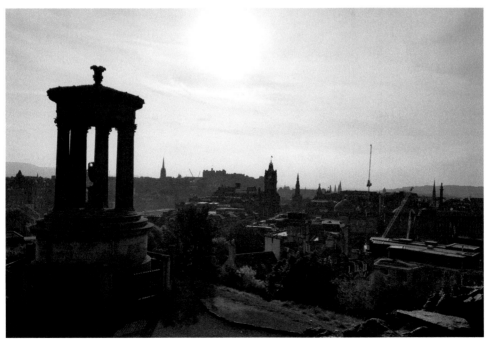

acted as drummer to the elves and sprites who met every week. The story was made famous in Richard Bovet's 1684 book *Pandæmonium, or the Devil's Cloister Opened.* Though a rather fanciful tale, it didn't stop Arthur Conan Doyle searching for these 'Little People'.

Nelson's Monument Dedicated to Admiral Nelson, who led the British fleet to victory against the French at Trafalgar in 1805, the building looks like an upside down telescope.

The Dugald Stewart Monument An 1831 memorial to the Scottish Enlightenment philosopher Dugald Stewart (*see* Ainslie Place). It is based on the Choragic Monument of Lysicrates in Athens (dating from 334 BC) and fronts a wonderful view over Princes Street.

Regent Bridge

In the early nineteenth century, entry to the New Town from the south meant traversing Low Calton, a steep ravine filled with shabby narrow streets. These were swept away and replaced by Regent Bridge, a major example of Greek revival architectural work. The bridge was designed by Archibald Elliot (1761–1823), who is buried in New Calton Cemetery, close by. Construction under the direction of Robert Stevenson (Robert Louis Stevenson's father) began in 1816 and the bridge was finished in 1819. The arch is 50 feet wide and around the same in height. The street along the top is Waterloo Place.

Interest Rating 2/5

Regent Bridge.

Old Calton Cemetery

In 1718, Old Calton Cemetery replaced the South Leith Parish Burial Ground. Cut down in size when Regent Road was built through the middle, it now hides behind a giant wall, blackened with age and traffic fumes.

Interest Rating 4/5

Abraham Lincoln Monument Built in 1893, this commemorates the Scots who fought and died for Union forces during the American Civil War. It also happens to be the first statue of a US President erected outside the USA.

David Hume Mausoleum His grave had to be guarded for eight days after Hume's burial, largely due to his being an atheist. Fortunately, his magnificent mausoleum is still intact. It was just to darned sturdy to knock down.

The Political Martyr's Monument In 1793, Thomas Moore and four accomplices, influenced by the French Revolution, campaigned for common man's voting rights. They were charged with treason and sentenced to fourteen years at Botany Bay in Australia. Their efforts are now commemorated by the gigantic Political Martyr's Monument, which looks like an accusing finger pointed at God.

Fun Fact One of the five, Thomas Palmer, remained in New South Wales after his sentence ended and established a thriving beer-brewing operation. Which is about as Australian as you can get.

Political Martyrs Monument,
Old Calton Cemetery.

Regent Road and Gardens

Extending from Regent Bridge, this major road has stunning views of Arthur's Seat and Salisbury Crags and includes a host of interesting erections.

Interest Rating 5/5

Rock House Just off Regent Road is a row of houses overlooking Waterloo Place. The last of these is Rock House, in which photography pioneers Robert Adamson (1821–48) and David Octavious Hill (1802–70) established a studio. Next came photographers Archibald Burns and, finally, Alexander Inglis, whose family worked there until 1929.

Fun Fact David Hill began as a respected painter who illustrated books by Robert Burns and Walter Scott.

St Andrews House Designed by Thomas Tait (1882–1954), who also constructed the pylons for Sydney Harbour Bridge. Opened the day after the Second World War was declared, St Andrew's House brought government departments serving Scotland under the same roof for the first time. It is one of the most significant examples of an art deco-style building in Scotland and principal office of the First Minister and the Scottish government.

Fun Fact It occupies the site of the former Calton Gaol (jail), now mostly demolished. The bodies of several executed murders still lie under the west car park.

New Parliament House (Royal High School) The building was designed by architect Thomas Hamilton (1784–1858), who also built the New Town's Royal College of Physicians, the Dean Gallery and the Martyrs' Monument on Calton Hill, as well as the Old Town's George IV Bridge and Bedlam Theatre. Now regarded as one of Europe's finest neoclassical structures, the building's portico and Great Hall are based on the Hephaisteion of Athens.

Regent Road.

The Royal High School can trace its roots back to 1128, making it one of the oldest in the world. In 1829 it moved into this purpose-built structure and stayed there until 1968, when it relocated to Barnton. The building has now lain empty for half a century, though it has been the proposed site of the Scottish Assembly, Scottish Parliament, a photography centre and a luxury hotel. But this is Edinburgh, so none of it happened.

Burns Monument Also built by Thomas Hamilton, in 1831, this is another fine example of Greek revival architecture. Like the Dugald Stewart monument on Calton Hill, it is based on the Choragic Monument of Lysicrates in Athens. Liked his Athenian stuff did Thomas Hamilton.

St Andrew's House.

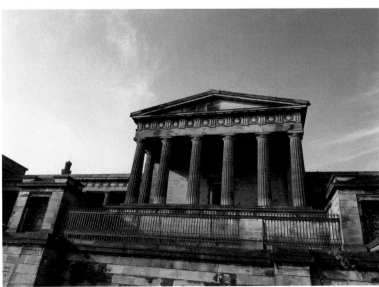

New Parliament House, Regent Road.

New Calton Cemetery Has a magnificent view overlooking Salisbury Crags, Holyrood Palace and the new Scottish Parliament buildings, with the Firth of Forth glimpsed in the distance. Though one of the most popular resting places for the poor, New Calton earned the impressive nickname 'Cemetery of Admirals', as there are six of them buried there.

Regent Terrace and Gardens

Both are parallel to Regent Road but much higher up. Hidden behind Regent Terrace are 12 acres of greenery, created between 1830 and 1832, the largest private gardens in the New Town. Ringed by trees, its layout has remained largely unchanged since then, so it's a pity that nobody but the residents can see it. The terrace curves into Calton Terrace, which is basically the same street.

Interest Rating 3/5

Haunted Rating 4/5 In 1979, one house in the terrace was plagued by a poltergeist. Crying and breathing noises could be heard in empty rooms, small valuables would vanish for days on end and something small and unseen would jump on beds when the occupants were in them. The people who lived there were eventually driven out.

Royal Terrace

Calton Terrace becomes Royal Terrace, designed by William Playfair in 1821 but not completed until 1860. The street began as family residences, though many of the buildings have now been turned into hotels. The elevated location was especially

Royal Terrace Gardens.

Greenside Parish Church.

popular with spirit merchants, who could spot their booze-laden ships docking at the Port of Leith, leading the area to be nicknamed 'Whisky Row'. It was also the home of John Crabbie (1806–91), maker of the legendary 'Crabbie's Ginger Wine'. On the other side is Royal Terrace Gardens.

Interest Rating 4/5

Fun Fact The gardens originally contained a specially built path for the exiled king of France, Charles X (1757–1836), allowing him to walk from the Palace of Holyroodhouse to church.

No. 1 Greenside Parish Church Sited on the 'green side' of Calton Hill, there has been a religious institution here since 1518. After the Reformation, the buildings fell into disrepair and even housed a leper colony. The present Gothic church was designed by James Gillespie Graham and opened in 1839.

Other Streets Worth Checking Out

On the other side of Royal Terrace Gardens is busy London Road and the maze of streets behind it make for a good meander. These include Elm Row, Windsor Street, Hillside Crescent, Brunswick Street, Hillside Street, Wellington Street, Brunton Terrace, Montgomery Street and Brunswick Road. On second thoughts, forget about Brunswick Road; it's horrible.

THE FRINGES

The New Town eventually petered out, rather than coming to an abrupt stop, and from the 1830s onward progress slowed in all directions. The last real burst of activity followed the 1831 completion of Thomas Telford's Dean Bridge (*see* Dean Bridge). This opened up the Dean Estate, where a few developments were built and some notable buildings constructed.

I've picked the streets I think are most noteworthy for one reason or another. But, once again, all these areas are worth discovering.

The Dean Estate

In 1592, James VI (1566–1625) gifted 'the landis of Dene', comprising Dean Village and some acres to the north, to James Lindsay (1554–1601). The Barony of Dean was subsequently bought by the Nisbet family and when, in 1827, the last of the Nisbets died, the estate was purchased by Lord Provost John Learmonth (1789–1858). He decided to build a bridge between the existing New Town and his lands, opening them up for development and making him richer than God's ex-wife. The bridge has become an Edinburgh landmark but the anticipated expansion didn't materialise as Learmonth had hoped. Instead it marks the North Western limit of the New Town.

Fun Fact The Nisbets of Dean held the office of Hereditary Poulterer to the King.

Haunted Rating 2/5 A groom spotted one of the younger Nisbets in regimental uniform, who looked at him sadly and faded away. It is alleged the man was shot at the same moment, fighting in the American War of Independence.

Queensferry Road and Dean Bridge

Queensferry road is a continuation of Queensferry Street, running over the Dean Bridge and joining the Dean Estate to the New Town. The bridge was built between 1829 and 1831 by the remarkable Scots engineer Thomas Telford (1757–1834), and spans a deep gorge with breathtaking vistas on both sides. Rising 106 feet above the Water of Leith on four huge arches, it became a popular site for suicides, earning the nickname 'Bridge of Sighs'.

Interest Rating 4/5

Fun Fact The bridge parapets were made higher in 1912 to try and prevent people jumping off. Didn't stop my friend Katie leaping over for a laugh when she was drunk. She had to wear a neck brace for weeks.

Thomas Telford, the 'Colossus of Roads', was one of the most influential builders of the nineteenth century. Apprenticed as a New Town mason in his

youth, he went on to construct numerous innovative tunnels, harbours, canals and bridges. The most famous of these are the Iron Bridge in Shropshire and the Menai Suspension Bridge in Wales, both of which are major feats of engineering. His network of Scottish canals and bridges opened up the highlands and helped make it a must-see tourist destination.

Fun Fact Telford's Caledonian Canal is 60 miles long and was first envisaged by his pal James Watt (1736–1819), the famed Scottish steam engine pioneer.

Holy Trinity Church This 1837 Tractarian Gothic building by John Henderson (1804–62) is on the north-west side of the Dean Bridge. It contains notable stained glass by Henry Holiday (1839–1927), the Pre-Raphaelite landscape painter, illustrator and sculptor. A former Episcopalian church, it has retained its original form and detailing despite being converted into an electricity transformer station in 1957. It is now the Rhema Christian Centre Church.

Fun Fact As well as having the world's most cheerful name, Holiday was an ardent socialist with an eclectic group of friends. These included the Pre-Raphaelite painters Dante Gabriel Rossetti, Edward Burne-Jones and William Morris, the suffragette Emmeline Pankhurst and the writer Lewis Carol (whose work he illustrated).

Daniel Stuart and Melville Colleges A towered and turreted Jacobean building designed by David Rhind in 1848. It was originally Daniel Stewart's Hospital for needy boys – basically an orphanage – before becoming Daniel Stewart's College in 1870. Melville College was founded in 1832 and amalgamated with Daniel Stewart's in 1972. Possibly the largest independent school in Europe, it has had a diverse range of noted pupils. These include David Wilkie (b. 1954), the only person to have been swimming

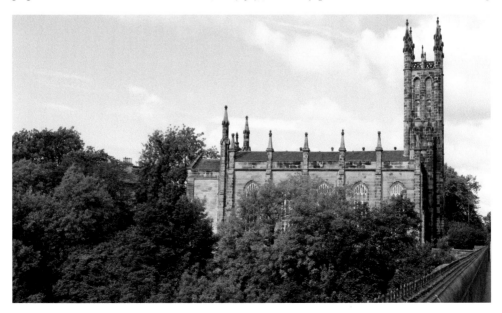

Rhema Christian Centre Church.

Daniel Stuart and Melville College.

champion at British, American, Commonwealth, European, World and Olympic levels at the same time and Professor Tom W. B. Kibble (1932–2016), theoretical physicist and co-discoverer of the Higgs boson.

Fun Fact Rhind is supposed to have based the building on a failed competition entry he submitted for the rebuilding of London's Houses of Parliament.

Buckingham Terrace

Built in 1860, this is an imposing crescent of houses, just above Queensferry Road, many of which are now divided into flats.

Interest Rating 3/5

Haunted Rating 3/5 The Gordon family, who lived there in the nineteenth century, were constantly disturbed by banging noises. A menacing but indistinct figure was sometimes seen in the furniture store above their house, often next to an antique grandfather clock. This frayed the family's nerves so much they eventually moved out. It was alleged that the house had belonged to an alcoholic sailor who was awakened by a crying child one night. In a fit of rage, he shook her to death and tried to hide her body in the clock casing. He was arrested and sent to a lunatic asylum, where he committed suicide.

Learmonth Terrace and Gardens

Built in the 1870s, on the other side of Queensferry Road from Buckingham Terrace, this small section of the Dean Estate is extremely pretty and best known for a couple of supernatural hotbeds.

Interest Rating 3/5

Haunted Rating 5/5 Staff at the Learmonth Hotel (Nos 18–20 Learmonth Terrace) have reported a whistling poltergeist that opens and closes doors. Guests have claimed

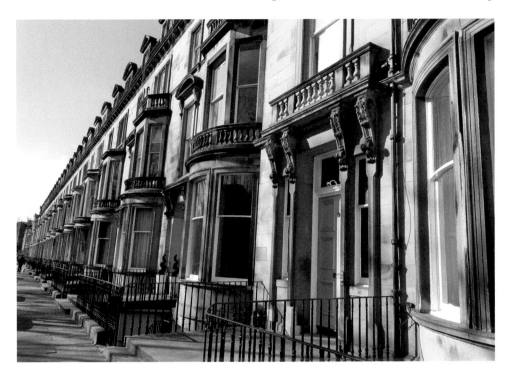

Learmonth Terrace.

that electrical appliances come on and doors lock and unlock by themselves. Then again, it's now a Travelodge, so it may just be faulty wiring.

In the 1930s No. 15 Learmonth Gardens belonged to Alexander Hay Seton (1904–63), 10th Baronet of Abercorn. On a 1936 trip to Luxor in Egypt, his wife secretly picked up a bone from a tomb that was being excavated and displayed it in their dining room. From that moment, the house was plagued by accidents, broken furniture, unexplained noises and flying objects. Such a story couldn't remain a secret long and the Edinburgh newspapers were soon full of stories of the 'Curse of the Pharaoh'.

The bone was finally exorcised and then destroyed. It didn't help the unfortunate baronet, who later wrote 'The curse certainly did not end when I destroyed the Bone by fire. From 1936 onwards trouble, sometimes grave, seemed to be always around the corner.' Shouldn't have stolen the bloody thing then.

Other Streets to Check Out
Clarendon Crescent, Oxford Terrace, Lennox Street, Eton Terrace, Belgrave Crescent, Dean Path, Ravelston Terrace and Belford Road.

Dean Village
Another part of the Dean Estate, this village had flour and weaving mills operating since the twelfth century, under the rule of King David I (1084–1153). Only the West Mill of 1805 is left, restored and turned into flats in 1973. The rest is a picturesque mishmash of eighteenth- and early-nineteenth century industrial buildings, cobbled

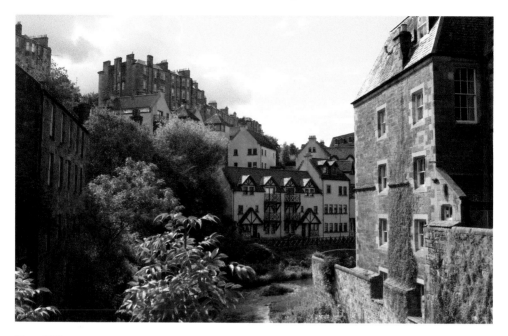

Dean Village.

streets and converted warehouses, giving the area a chocolate-box charm. And all of it is completely hidden from the rest of the city by being at the bottom of a huge valley, accessed by the off-puttingly steep Bell's Brae.

Interest Rating 5/5

Well Court The most striking building in Dean is a square red Teutonic block with an enclosed courtyard and clock tower. Built in the 1880s, it was a Victorian experiment by the philanthropist J. R. Findlay (*see* Rothesay Place) to house local millworkers. It is well worth a look, as it was recently restored. I used to live there too.

Dean Gardens 7 acres of verdant valley, with the Water of Leith running along the bottom. It is unique among Edinburgh's private gardens because anyone can apply for a key, so long as they pay a fee. It's not cheap, though.

Dean Cemetery A historically important and spectacular-looking Victorian cemetery, north of Dean Village. Designed by David Cousin in 1845, it occupies the site and grounds of the old Dean House, now demolished. It was mainly reserved for the middle and upper classes and holds many later Scottish Enlightenment figures. 'Lord's Row' is the most famous part, containing an astonishing array of New Town celebrities.

Dean looks much the same today as it did when it was opened and is considered a valuable resource of Victorian art, with markers and monuments designed by many eminent artists, sculptors and architects.

Fun Fact One of the most interesting interments is Lieutenant John Irving, an officer on the ill-fated 'Franklin Expedition' of 1845, which set out to find the fabled North West Passage. The ships got stuck in ice and the expedition force perished, after turning to cannibalism in a desperate effort to stay alive. After years of searching, Irving's body was eventually found by the United States Navy and returned to Scotland.

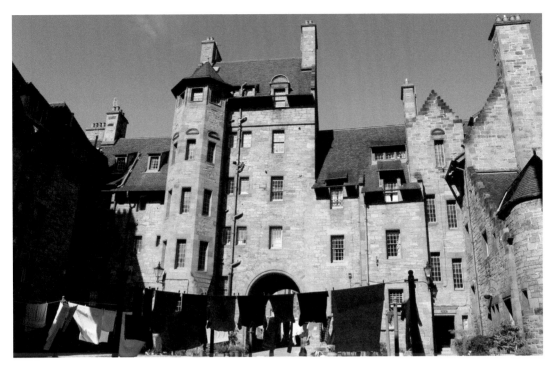

Well Court, Dean Village.

Dean Cemetery.

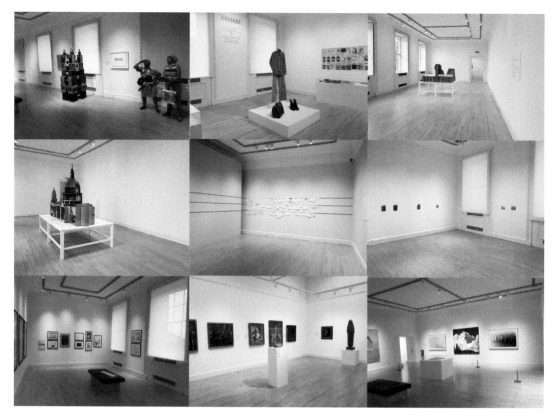

Gallery of Modern Art One.

Scottish Gallery of Modern Art

Where the Water of Leith threads through Dean Village you'll spot a small unobtrusive path alongside the river. Follow it (which is a treat in itself) and you'll come to the Scottish Gallery of Modern Art. Modern One was originally John Watson's Hospital and school, designed in 1825. Modern Two is the former Dean Gallery, a baroque-style building built by Thomas Hamilton and opened in 1833 as an orphan hospital. It contains a recreation of the sculptor Eduardo Paolazzi's (1924–2005) workshop, as well as his huge sculpture *Vulcan*, situated in the café. Both galleries display paintings by some of the world's most illustrious artists, including a large collection of Dada and Surrealist work.

Interest Rating 5/5

Stockbridge

Named after a footbridge where cattle were driven over the Water of Leith to market, Stockbridge was originally an isolated village. That changed in 1813, when local landowner and painter Sir Henry Raeburn transformed the area with the help of architect James Milne. Residential development continued into the 1860s, including construction of the Stockbridge Colonies, providing low-cost housing for workers. These form eleven parallel streets, not far from the Botanic Gardens, running from Glenogle Road to the south bank of the Water of Leith. There's no way that any working-class person could afford one now.

Shopfronts,
Stockbridge.

A buzzy, ambient location, it is one of the last places in Edinburgh with truly independent retailers.

Interest Rating 5/5

Haunted Rating 2/5 Cheyne Street was home to Jessie King, the 'Stockbridge Baby Farmer'. In the eighteenth century she took in orphans for payment and then murdered them. She was hanged in 1889 and is now said to haunt the area.

Self-taught artist Henry Raeburn was born in Stockbridge but orphaned at fifteen. Marrying into money, he studied art in Italy before returning to Edinburgh in 1787, beginning a successful career as a portrait painter. His powerful characterisation, stark realism and unusual lighting effects are all the more remarkable for being painted directly from life, with no preliminary sketches. Raeburn made more than a thousand paintings, including portraits of Enlightenment giants like Robert Adam, William Creech, Henry Dundas, Niel Gow, Thomas Charles Hope, James Hutton, Lord Braxfield, John Playfair, Sir Walter Scott, Dugald Stewart and Hugh William Williams (who coined the term 'Athens of the North'). Raeburn is buried in St Cuthbert's Churchyard in Princes Street and has a memorial there, with another in the Church of St John the Evangelist next door.

Deanhaugh Street

Running into Raeburn Place, these are the two main streets of Stockbridge, lined with all sorts of interesting shops.

Interest Rating 4/5

No. 1 Pizza Express It might seem odd to include a Pizza Express but this mid-nineteenth-century former bank, with its an idiosyncratic clock tower, has been ingeniously converted and looks over the water of Leith.

Deanhaugh Street was also the residence, for a time, of the famous poet and novelist James Hogg (1770–1835). This self-educated farmhand was known as the 'Ettrick Shepherd' and his most famous book is the fantastic *Private Memoirs and Confessions of a Justified Sinner*. An early example of crime fiction, years ahead of its time, it was a damning critique of religious fanaticism, featuring an antihero who is either possessed or schizophrenic, depending on how you interpret it. Either way, it was the first novel to tackle such subject matters and completely ignored by the public. But there's a good case to be made that it was a major influence on Robert Louis Stevenson's *The Strange Case of Dr Jekyll and Mr Hyde*.

Water of Leith/St Bernard's Well

From Deanhaugh Street you can take Saunders Street and find that well-hidden path along the Water of Leith Walkway to Dean Village. It's a fantastic stroll, which takes you under the towering Dean Bridge. On the way it passes St Bernard's Well, a circular temple containing a statue of Hygeia, Greek and Roman goddess of health. According to legend, three schoolboys found a hidden mineral spring here in 1790, which quickly became famous for its rejuvenating powers. It was immensely popular with the Victorians, who loved that kind of quackery. I wouldn't drink the water now, though; it's got dead stuff in it.

Interest Rating 5/5

St Bernard's Crescent/Danube Street/Upper Dean Terrace

St Bernard's Street is probably the most imposing thoroughfare in Stockbridge, with a charming private garden in front. Running off it are the smaller but no less impressive Danube Street then Upper Dean Terrace, with a spectacular and little-seen view of Randolph Cliff and St Bernard's Well.

Interest Rating 4/5

No. 17 St Bernard's Crescent Home of Henry Raeburn, notable for grand Grecian Doric pillars buttressing the house. St Bernard's Crescent was also the home of the novelist Leitch Ritchie (1800–65), author of *Wearyfoot Common*. His neighbour and friend (at No. 33) was Andrew Crichton (1790–1855), author of *A History of Scandinavia* and editor of the *Edinburgh Advertiser*.

Fun Fact Ritchie wrote one of the first werewolf tales, *The Man-Wolf* (1831).

Danube Street No. 17 was home of Dora Noyce (1900–77), a refined matronly woman and Scotland's most infamous madam, running a brothel at this address from the end of the Second World War until the mid-1970s. She hated the word brothel, calling her establishment a 'YMCA with extras', and even served tea to her customers. Despite

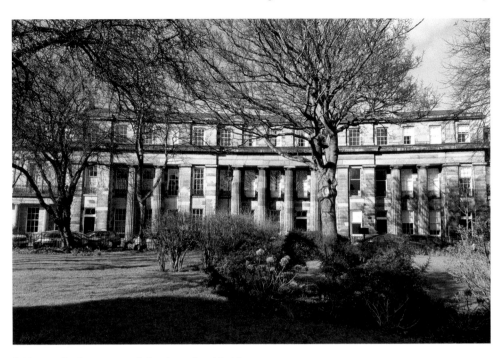

St Bernard's Crescent and Gardens, Stockbridge.

St Bernard's Well, Randolph Cliff and the Water of Leith from Upper Dean Terrace.

her sophisticated airs, she was born in Rose Steet, when it was rough as a builder's thumb, and worked as a call girl. When navy ships docked at Leith, queues for her establishment are said to have stretched all the way to Ann Street. She was arrested more than forty times and served her last prison term at the age of seventy-one. The property has now been converted into flats.

Ann Street

Developed in 1814 and named after Raeburn's wife, the street is unusual in having front gardens, making it one of the most scenic lanes in the city. Its residents included the publisher Robert Chambers (1802–71) and John Wilson (1785–1854), who wrote under the name of Christopher North. An advocate, poet, literary critic and professor of Moral Philosophy at Edinburgh University, North is buried in Dean Cemetery. There is a statue commemorating him in Princes Street Gardens by Sir John Steell, unveiled in 1865.

Interest Rating 4/5

Fun Fact North was only twelve when he was enrolled in Glasgow University. He became firm friends with William Wordsworth, Samuel Taylor Coleridge and took in Thomas De Quincy as a lodger.

Haunted Rating 3/5 Haunted by a small man dressed in black called Mr Swan, a former nineteenth-century resident who died overseas. He popped up at his old house over the years and was eventually exorcised, though all he did was hang around smiling. The exorcism seemed to work until the house was sold in 1936, when Mr Swan began to appear again.

Ann Street.

Perhaps he liked the new occupants better, for the children there often claimed that he would come and say goodnight when they went to bed. Cause *that's* not creepy.

Other Streets to Check Out
India Place, Kerr Street, St Stephen Street, Saxe Coburg Place, Clarence Street, Hamilton Place, Raeburn Place, Cheyne Street, Dean Street, Leslie Place and Dean Terrace.

Canonmills
Once royal land, Canonmills was gifted by King David I to the Augustinian monks who worked the mills here. As late as 1850 it was a rural area with bleaching grounds, orchards and corn fields. Only one mill remains, on the corner of Eyre Place and Canon Street, though it has been converted into offices. This is where the Northern New Town sort of fades away, as the grand scheme stagnated and development halted, regimented Georgian tenements being replaced with many other types of buildings. It's all a bit rundown these days, so I've only listed the highlights.
Interest Rating 3/5
No. 8 Howard Place Robert Louis Stevenson was born here before his family moved to Heriot Row.

Scotland Street Tunnel, George IV Park.

No. 10 Warriston Crescent This was where composer Frederic Chopin (1810–49) stayed at the home of Polish-born doctor Adam Lyszczynski. Nearing the end of his life, Chopin's health was so poor he had to be carried upstairs to bed. Vain, snobbish, anti-Semitic and prone to bouts of depression, he probably wasn't the most congenial house guest.

Canonmills Clock In the centre of the road junction at the bottom of Brandon Terrace and Dundas Street, this notable late art deco landmark was designed by Leslie Grahame (1896–1974) to celebrate the allied victory in the Second World War.

Botanic Gardens

At the edge of Canonmills, off Inverleith Row, sit 70 acres of peace and quiet, with an amazing range of exotic plants and lush landscapes. It was founded in 1670 near Holyrood Abbey in the Old Town and moved to its present site in 1820. The main attraction is a set of Victorian glasshouses containing a palm tree so high that King Kong would baulk at climbing it.

Interest Rating 5/5

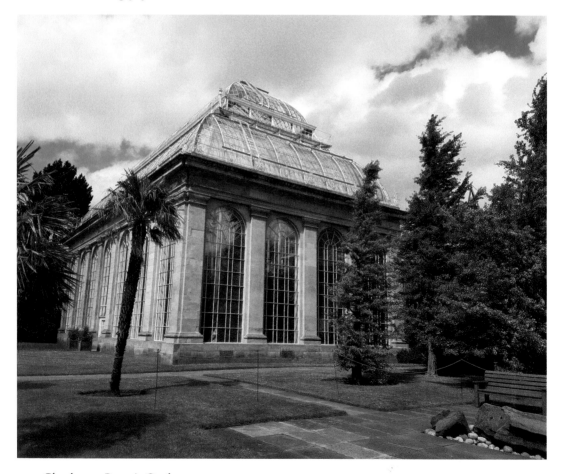

Glasshouse, Botanic Gardens.

Other Streets to Check Out
Eyre Place, Brandon Street, Henderson Street, Glenogle Road (plus all the tiny mews lanes running off it), Bridge Place and West Silvermills Lane.

Gardner's Crescent
A true anomaly and separate from the rest of the New Town, it lies on the other side of the financial district, near Fountainbrige and the Union Canal (also well worth a look). Built in the 1820s as a plain classical Georgian crescent of four-storey tenements, the name came from William Gardner who feued out the land. It was originally intended to be a circus with a garden in the middle, until the colony housing of Rosebank Cottages was built on the opposite side. This was a notable example of nineteenth-century model workers' housing, so a wall was built in front to prevent any mixing of the classes.

The garden was recently renovated but it was a botched job. Healthy adult trees were cut down and restored railings made it a perfect dog toilet. As the New Town has always demonstrated, success requires adaptability more than rigidity but, unfortunately, Edinburgh's present councillors are a pale shadow of their forbearers. I should know, I lived at No. 20.

So, like many Scots before me, I upped and moved to Australia.
Interest Rating 3/5

And that's the New Town. A place where you can walk into the past and experience things the way they used to be. Unlike the Old Town, it's an area where you won't be bombarded by tartan tat, giant walking tour parties or wheelie bins that never do get emptied. Steer clear of Princes Street and you can avoid chain stores and find shops that sell something you haven't seen before. It's a site where commerce, retail and residents coexist harmoniously in historic surroundings that are beautiful as well as being fully functional.

How many places in the world can you say *that* about?

No. 20
Gardner's
Crescent.

BIBLIOGRAPHY

Ainslie, John, *City of Edinburgh*, 1780

Ansdell, Ian, *Strange Tales of Edinburgh* (Edinburgh: Lang Syne, 1975)

Arnot, Hugo, *The History of Edinburgh* (West Port Books)

Birrell, George, *Edinburgh Princes Street and New Town* (Edinburgh: Gemini, 1986)

Birrell, J. F., *An Edinburgh Alphabet* (Edinburgh: Mercat Press, 1980)

Black, George F., *Scotland's Mark on America* (New York, 1921)

Boece, Hector, *Historia de Scotia* (Paris, 1527)

Books of the Old Edinburgh Club (Vols I to present)

Brander, Michael, *The Emigrant Scots* (Constable and Co., 1982)

Ed Brown, Iain Gordon, *Elegance and Entertainment in the New Town* (Rutland Press, 1995)

Buchanan, George, *The History of Scotland* (Churchill, 1690)

Byrom, Connie, *The Pleasure Grounds of Edinburgh New Town, Garden History*, (1995)

Campbell, R. H., *Scotland since 1707* (Oxford, 1977)

Carley, Michael, Robert Dalziel, Pat Dargan and Simon Laird, *Edinburgh New Town: A Model City* (Stroud: Amberley Publishing, 2015)

Chambers, Robert, *Domestic Annals of Scotland* (1858)

Chambers, Robert, *Traditions of Edinburgh* (London, 1824)

Cockburn, Henry, *Memorials of his Time* (1856)

Cohen, Daniel, *Encyclopaedia of Ghosts* (Michael O Mara Books, 1984)

Colvin, Howard, *A Biographical Dictionary of British Architects 1600–1840* (Yale, University Press 1995)

Daiches, David, *Edinburgh* (Granada Publishing, 1978)

Dawson, Jane E., A, *Oxford Dictionary of National Biography* (Oxford University Press, 2004)

Doren, Charles Van, *A History of Knowledge* (Ballantine Books, 1991)

Ed Lynch, Michael, *The Oxford Companion to Scottish History* (Oxford University Press, 2001)

Edinburgh and Places Adjacent, 1580–1928 (National Library of Scotland)

Edinburgh Visitors' Guide (Collins, 1999)

Ellis, Havelock, *A study of British Genius* (Boston, 1926)

Feintuck, Anna, *Urban History* (2017)

Fife, Malcolm, *The Nor' Loch* (Edinburgh: Pentland Press, 2001)

Fleet, Christopher and Daniel MacCannell, *Edinburgh: Mapping the City* (Birlinn: Edinburgh 2014)

Geddy, John, *Romantic Edinburgh* (1921)

Gifford, John; McWilliam, Colin; Walker, David *The Buildings of Scotland*, (Edinburgh: Penguin Books, 1984)

Gilbert, W. M., *Edinburgh in the Nineteenth Century* (Edinburgh, 1901)

Gillon, J. K., *Eccentric Edinburgh* (Moubray House Publishing)

Goring, Rosemary (Ed), *Chambers Scottish Biographical Dictionary* (Edinburgh, 1992)

Gow, Ian, *The Scottish Interior: Georgian and Victorian Décor* (Edinburgh, 1992)

Grant, James, *Cassell's Old and New Edinburgh* (London & New York: Cassell, Petter, Galpin & Co., 1881)

Gray, W. Forbes, *Historic Churches of Edinburgh, Edinburgh & London* (The Moray Press 1940)

Grierson, Flora, *Haunting Edinburgh*

Harris, Stuart, *The Place Names of Edinburgh* (Edinburgh: Gordon Wright Publishing, 1996)

Harrison, Wilmot, *Memorable Edinburgh Houses* (1893)

Henderson, Jan-Andrew, *The Town Below the Ground* (Edinburgh: Mainstream, 1999); *The Emperor's New Kilt* (Edinburgh: Mainstream, 2000); *The Ghost That Haunted Itself* (Edinburgh: Mainstream, 2001) *Edinburgh: City of the Dead* (Edinburgh: Black and White, 2004)

Herman, Arthur, *The Scottish Enlightenment* (London: Fourth Estate, 2001)

Holinshed, *Chronicles of England, Scotland and Ireland* (London, 1577)

Keay, John and Julia (ed), *The Collins Encyclopaedia of Scotland* (Harper Collins 1994)

Keir, David, *The City of Edinburgh, The Third Statistical Account of Scotland*

Littlejohn, Henry, *Report on the Sanitary Condition of the City of Edinburgh* (Edinburgh 1863)

Lochhead, Marion, *Edinburgh Lore and Legend* (St Edmundsbury Press 1986)

Mackay, John, *History of the Barony of Broughton* (1869)

Mackie, J. D., *A History of Scotland* (New York, 1964)

Maitland, W., *A History of Edinburgh*

McCosh, James, *The Scottish Philosophy* (New York, 1875)

Minto, C. S., *Edinburgh, Past and Present* (Oxford Illustrated Press)

Pope, James, *Robert Louis Stevenson* (1974)

Royal, Trevor, *Precipitous City* (Edinburgh: Mainstream Publishers, 1980)

Smith, Mrs J. Stewart (1924), *Historic Stories of Bygone Edinburgh* (T&A Constable Ltd)

Smith, Robin, *The Making of Scotland* (Canongate Books, 2001)

Steel, Tom, *Scotland's Story* (Collins, 1984)

Stevenson, Robert Louis, *Picturesque Old Edinburgh* (Albyn Press, 1983)

Turnbull, Michael, *The Edinburgh Book of Quotations* (Black and White) *Edinburgh Portraits* (John Donald Publishers Ltd) *Edinburgh Characters* (St Andrew, 1992)

Underwood, Peter, *Gazetteer of Scottish Ghosts* (London, 1974)

Wallace, Joyce, *The Historic Houses of Edinburgh* (Edinburgh: John Donald, 1987)

Wallace, Joyce M., *Great King Street and the Second New Town of Edinburgh* (Great King Street Association, 1972)

Watt, Francis, *The Book of Edinburgh Anecdotes* (London, 1913)
Wills, Elspeth, *Scottish Firsts* (Glasgow: Scottish Development Agency, 1985)
Wood, Margaret, *Edinburgh 1329–1929 & Survey of the Development of Edinburgh*
Youngson, A. J., *The Companion Guide to Edinburgh and the Borders* (Edinburgh: Polygon Books, 2001) *The Making of Classical Edinburgh* (1966)